The young Ardizzone

An autobiographical fragment

Edward Ardizzone

THE MACMILLAN COMPANY

First published in Great Britain by Studio Vista Limited
Copyright © Edward Ardizzone 1970
All rights reserved. No part of this book may be reproduced or transmitted in
any form or by any means, electronic or mechanical, including photocopying,
recording or by any information storage and retrieval system, without permission
in writing from the Publisher.

The Macmillan Company
866 Third Avenue, New York, New York 10022
Library of Congress Catalog Card Number: 71-125295
Printed in Great Britain
First American edition

Contents

Preamble

I was born, the eldest of five children, on 16th October 1900, in the town of Haiphong in the province of Tonkin.

My father, French by nationality but Italian by blood, was employed by the Eastern Extension Telegraph Co. My mother was half Scots and half English. In 1905 she brought me and my two sisters to England, which has been my home ever since.

As I have little or no memory of the long voyage, nor of our first few months in the London suburb of Ealing, I will begin these memoirs with our arrival at the small Suffolk village of East Bergholt. Why my mother chose this remote village I cannot tell. I can but conjecture.

Her mother, my maternal grandmother, had been a Miss Kirby. Daughter of old Captain Kirby, master of one of the great sailing ships in the China trade, she was born at sea off the Cape. The captain was an excellent artist and illustrated his private log books with many drawings of everyday happenings on board his ship; these, as a boy, I loved to look at. He, in turn, was the son of the

Rev. Lawrence Kirby, an eccentric parson of Thorpe le Soken in Essex. The parson, who was well known as an amateur water-colourist, claimed to be the direct descendant of Joshua Kirby the eighteenth-century painter and Gainsborough's bosom friend. Perhaps it was the East Anglian connection which drew my mother to this small village on the Essex-Suffolk border.

An additional reason may be that my mother was something of a painter herself. She had done that unusual thing for a young English woman, she had studied painting at Colorossi's in Paris in the 1880s, continuing to paint in watercolour from time to time for the rest of her life. Constable was her favourite painter and it is possible that she wanted to settle her family down in Constable country.

Of my father you will find little in the following pages. This is because he was abroad for much of the time and only visited home on rare occasions. My mother too would leave us for years at a time when she went to join my father in the Far East.

So it was my grandmother who loomed large in our young lives. Indeed she loomed in more ways than one, for she was immensely stout and had a formidable temper. But I must not anticipate.

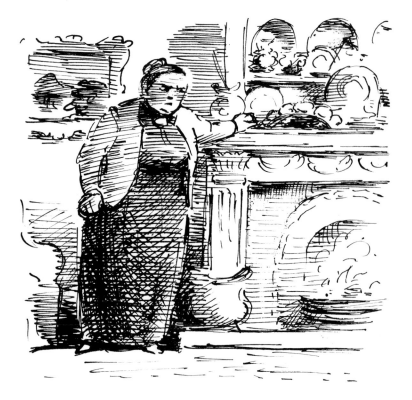

East Bergholt

Old memories are strange in the sense that one never can be sure how true they are. The most vivid of them are probably fairly accurate, even allowing for time and nostalgia to make the inevitable changes. Half and quarter memories are a different matter. What truth is there in them? Some may be quite fictitious but believed in just the same.

Often I would prefer to use, instead of 'I remember', the phrase 'I think of so and so as', or of 'such and such as'. For instance, my most vivid memories of those early days in East Bergholt are of the shop, and I can truthfully say that I remember it. On the other hand, of Mrs Tweed who owned the shop I would rather say I think of her as a middle-aged plump partridge of a woman, a dark brown shadow in the shadows behind the counter at the back of the shop. But I would not swear to this in a court of law.

I think of Mr Tweed as a tall thin man, with a very pale face and very black hair and a very sweet, gentle manner, but again I could not swear to this. Yet I can swear to the fact that he produced the most delightful decorated hens' eggs for our first Easter in the village; I remember them well. They were beautifully coloured and delicately patterned by scraping the shell with a knife. Poor Mr Tweed. We learnt later that he suffered from a mental sickness and from time to time would have to spend a period in the local mental hospital.

I remember this shop so well because my mother had rented rooms beside and behind it and, in a sense, the shop was almost part of our home.

As you went into the shop from the street entrance, to the left, right and facing you, making a smaller square in the larger square of the room, were rods attached by brackets to the ceiling. From these rods hung a strange assortment of goods: clothes of every kind, trousers, shirts, sunbonnets and pinafores. Then lengths of cloth, nests of galvanized buckets, a tin bath or two — in fact anything that could be conveniently hung up. These cast dark shadows on the three facing walls and the counters which lined two of them.

In the centre was an enormous pyramid of assorted merchandise. At the base were buckets, scrubbing brushes, garden shears, flower pots and hanks of bass. Above that pots and pans and various articles of kitchen hardware. Above that again, cotton reels, collar studs,

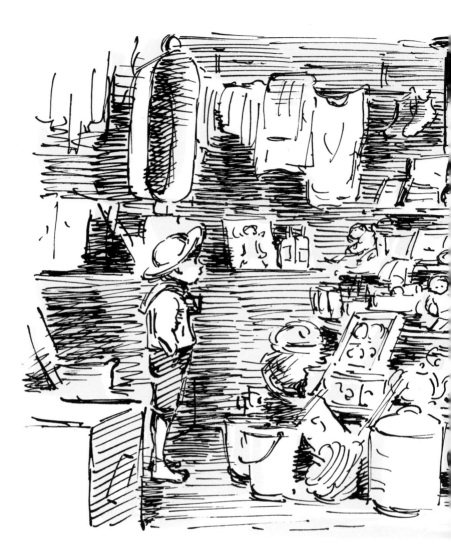

glass balls which, when you shook them, produced an internal snow-storm, glass paperweights, now so valuable, coloured wools, dolls, notepaper, cheap toys and so on, almost to the ceiling.

On the shelves behind the two counters were ranged many of the old proprietary medicines: Dr Collis Browne's Chlorodyne, Scott's Emulsion, syrup of figs, Mrs Seigal's Syrup, Gregory Powder, liquorice powder, cold drawn castor-oil, Beecham's Pills, iodine and many powerful laxatives. Some of these we knew to our cost, liquorice powder being for me the most hated.

Also on these shelves were various groceries and sweets arranged in no very precise order. You might easily find the aniseed balls next

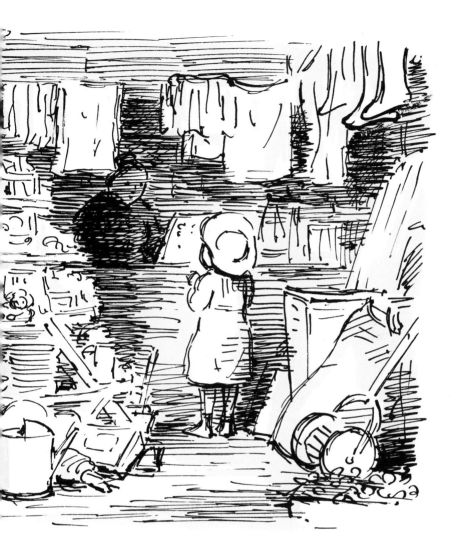

to the chlorodyne or bags of sherbet shoulder to shoulder with the Gregory Powder.

Many of the groceries were sold loose, rice, sugar and beans being shovelled out of drawers with a scoop. If your mother asked you to buy an ounce of pepper it was weighed on a scale and handed to you in a twist of paper.

Sweets, of course, were our usual purchase and aniseed balls the favourite. They were round and smooth and immensely hard so they took a long time to dissolve in the mouth. They were so hard that chewing was impossible. They cost a farthing an ounce. For a farthing too one could buy a bag of sherbet with a hollow stick of

liquorice to suck it up. Both these were in our price range, our weekly pocket money being but a penny.

The wall without a counter was lined with sacks of seed potatoes, fertilisers, drums of oil and heavy garden implements, all in the most delicious confusion.

For three small children of five, four and two respectively and new to England from distant China, this shop was something of a paradise.

It was not long before my grandmother installed herself in a house in the village. It was not large, but roomy enough, and my mother and the three of us moved into it to live with her. The house, which was at the end of a row of white houses, was called 'The Gothics'. Its front was probably eighteenth century but gothic was quite an apt description of the back, with its dark beams and odd flights of stairs.

With the house we acquired a staff, including a cook in the most traditional mould. I see her again in Leech and Du Maurier drawings. She was stout, pink faced, wore her cap askew and her hair stuck out in spines from under it. Then we had a dim tweeny maid whom I can't visualize at all and an adenoidal boy, a sort of village buttons. His job in the morning was to clean the boots and the knives and help in the house. In the afternoon, resplendent in a buttoned jacket and white gloves he would open the door to visitors. Finally there was Nurse Spencer.

Nurse Spencer was a village girl and by no means a true nanny.

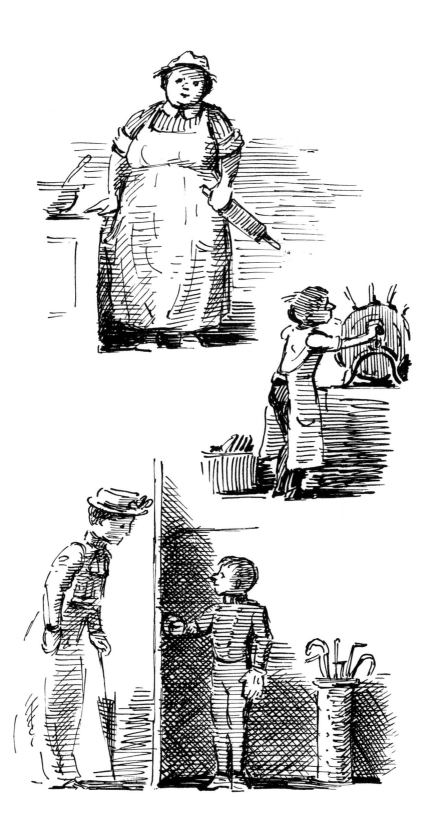

Considering that I have a photograph of her I should, apart from her face and figure, remember her better. Yet only two things about her stick in my mind. First the village gossip she would purvey to us at meal times in the nursery, and which, though only half understood, intrigued us enormously. I think my mother would have been horrified had she realized what we knew about the goings on in the village. Tales of difficult childbirths, horrid diseases, drunken husbands and unfaithful wives were soon no longer novelties but taken in our stride.

And second, Nurse Spencer's habit of imbibing neat vinegar by the pint. This, she contended, produced that pale complexion so fashionable at the time, and indeed it seemed to succeed admirably.

Her skin was as white as wax. With her tall but buxom figure, fine features, coal black hair and dead white skin, dressed all in black, which she favoured for going out, she was certainly a striking figure.

When older and more mobile we would roam the nearby fields. It is curious that when at home we refused (or at least I did) to eat boiled cabbage, spinach, parsnips or turnips, while once in the fields we would eat a variety of things without a qualm. There was the leaf

of the May bush which we called bread and butter — or was it bread and cheese? Then wild sorrel and, when I was old enough to carry a pocket knife to cut them up with, raw swedes and turnips. We were also partial to dog biscuits as a between-meal snack and once, at Flatford Mill, ate some cattle cake, which we pronounced delicious.

Of course, this failure to eat wholesome vegetables dished up at meals led to dire trouble. I was stubborn and got the worst of it. Many a time I had to sit over cold cabbage at tea time — cabbage that was left over from lunch because I had refused to eat it then. When I persisted in my stubbornness my grandmother would beat me with the back of a hair brush in an effort to make me eat. But I always won: I was invariably sick and that was the end of it.

It was at about this time that I and my eldest sister, Betty, decided to run away. We had tasted of the fruits of the countryside and felt we could well support ourselves on them. We planned to sleep out for at least one night, in a grassy dell free of cowpats. Our supper was

to be of May leaves, swedes and ripe blackberries. Alas, we never carried out our plan.

My mother found us at dusk. She had hired an open carriage and standing up in it peered from left to right in search of us. I can well remember my first sight of her, her anxious face under a big hat, bobbing along above the hedge against a darkening sky. Curiously enough I can't recall the scolding that must have followed.

Unfortunately I have forgotten much of that early time. In that first summer at East Bergholt I was still not six. I and my sisters

were little children and much in thrall to grown ups. Our walks were limited and supervised, the distance being governed by how far Nurse Spencer wished to push my youngest sister in her pram.

Yet certain memories are with me still. A particular picnic in a hayfield during haymaking; a fine summer afternoon in a cornfield when the stooks of corn became our wigwams. A certain rutted lane with oak trees arching overhead and hedges so high that the lane looked like a green tunnel leading to the flats below.

The grass verges of this lane contained a profusion of wild flowers. Periwinkles, wild geraniums, violets mauve and white, ragged robin, lords and ladies and many others. In the hedges were sparrows and finches, blackbirds and thrushes and here and there the tiny wren which would dart out from the small leaved ivy at the front of the hedge. Two birds which we often saw then, but which are rarely seen now, were the yellow hammer and the sparrow hawk. Butterflies abounded.

Not far from the old parish church, with its strange bell cage planted down among the tomb stones, was a road bounded on one side by a very high red brick wall. Set in this wall was a small gothic door. It was of wood and decorated with heavy iron studs. Beside this door was a wrought iron bell pull.

It was the back door to a convent of an enclosed order of nuns. When you pulled the bell a deep clanging came from beyond the wall, then footsteps sounded and the door was opened by an elderly lay sister.

This door fascinated me and even frightened me a little, though I realize now my fear was irrational. Being Catholics we often went through it on our way to Mass in the convent chapel. Perhaps it was the iron studs that did it, reminding me of something seen in a children's book. A door to the dungeons in an ogre's castle? Always, if sent to the convent on some errand and having to go through the door by myself, I had a feeling of apprehension that I would never get out again.

About this time there was a great occasion at the convent. Two of the novices were taking their final vows. The Bishop officiated at the ceremony with the help of a number of attendant priests, and I

took part as the youngest altar boy. I am sure my mother thought I looked angelic in the part. I was scrubbed clean, my hair smoothed down. I wore a scarlet cassock with a white lace cotta over it and on my hands white cotton gloves. My duty, during one short part of the ceremony, was to carry the Bishop's mitre.

Now the main body of the chapel was the nuns' portion and was screened from the altar by a high grille. The laity occupied a side chapel at right angles. Looking to my right I could just see through the grille the two novices clothed in white habits. They lay side by side and face down on the floor. Behind them were the nuns in the choir singing in their high voices. Ahead of me in the side chapel I had a glimpse of my mother and eldest sister.

All this distracted me, but what distracted me more was that our dear elderly parish priest had not done his homework. He was pushed here by one priest and shushed there by another, even the

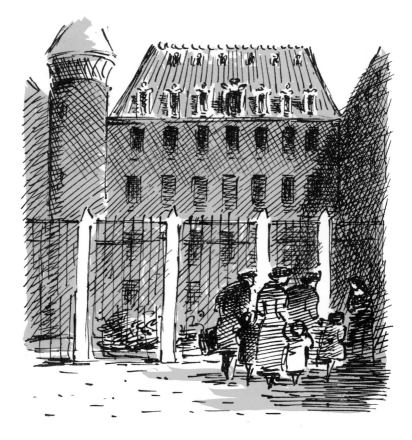

Bishop frowned at his mistakes. This was too much for me. In a happy daze and to my subsequent shame and confusion I dropped the mitre.

In the winter of 1906 my grandmother took us all, that is, my mother, myself and my two sisters on a flying visit to Bruges. The purpose of the visit was to see my Aunt Grace who was a nun in a retreat convent in this city.

The convent was a very tall, gothic building in red brick on two sides of a small gravelled courtyard. The third side of this yard was bounded by the blind wall of another building and on the fourth side was a high iron railing facing on to a narrow, cobbled street. A door in this railing gave access to the yard. Having rung the bell one would, after due scrutiny, be admitted by the lay sister who inhabited a small room, like a military guard room, by the gate.

Inside the building there was a wide hall, the floor of which was of highly polished wood and very slippery, a common phenomenon in convents. Out of this hall rose a great staircase, slippery too with

polished wood. All seemed overshadowed by a statue of the Sacred Heart. To my childish mind this hall was huge and I was lost in its immensity.

Inevitably we children were subjected to a great deal of kissing and hugging by my aunt and affectionate nuns; but in a way we rather disliked this. Nuns' habits are voluminous and stifling; enfolded in a nun's embrace, you felt you would never breathe again and the sooner you could get out of it the better.

The nuns, besides running a retreat house for women, also ran a small orphanage for girls, and I and my eldest sister would breakfast with them each morning. We liked these girls, though, as most of them were Flemish, we did not understand their language. They were of all ages from our own to the late teens. Old and young were

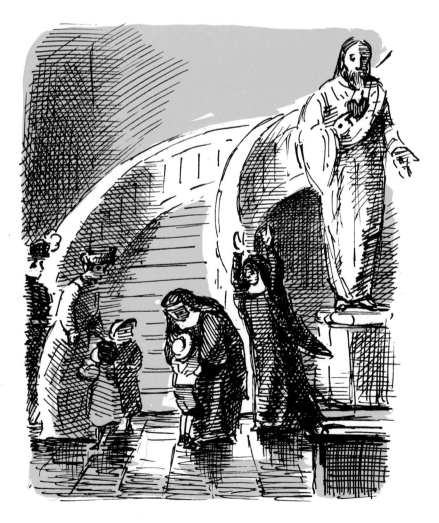

dressed alike in grey pinafores buttoned down the back, black stockings and boots.

What surprised us at these breakfasts was their habit of dunking their tartines in their coffee which was served in bowls. We were not allowed to do this at home, so this was a glorious new freedom. Gladly we followed their example and dunked away, admiring as we did so the round globules of butter which floated on the surface of the coffee. Once at home we tried it on again and, of course, were reproved.

At that time Bruges was deep in snow and there was ice on the canals. To us it was a fairy city and a strange one. The milkman's float was mounted on runners and pulled by two dogs harnessed underneath. Many other small carts either on wheels or on runners were drawn by dogs too. Occasionally one saw a horse-drawn sleigh. Grown-ups and children wore wooden sabots; skaters cut figures on

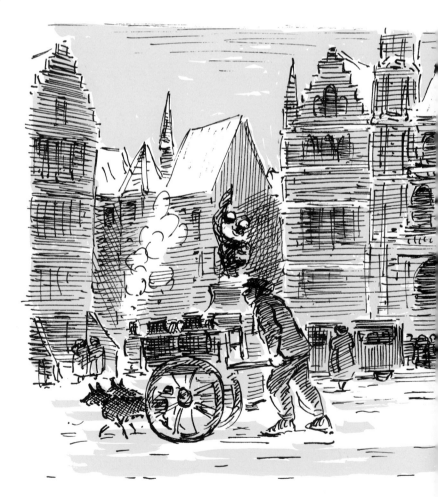

the ice; the steam tram to Knocke puffed through the Grand Place. Perhaps best of all were the stalls under the belfry which sold beignets piping hot and dipped in powdered sugar.

My mother took us to a shop where she bought sabots for the three of us. An elderly man in shirt sleeves and wearing a leather apron carved, while we waited, a different design on each pair. It was most exciting to watch him do this, his chisel gliding through the wood as if it were butter.

Towards the end of our stay there was the drama of my eldest sister's hair. In the convent parlour was a large table covered by a woollen cloth trimmed with little bobbins; this hung down all round till it almost touched the floor and made a fine, dark tent for us to play in.

One afternoon we installed ourselves underneath it with, unfortunately, a pair of scissors.

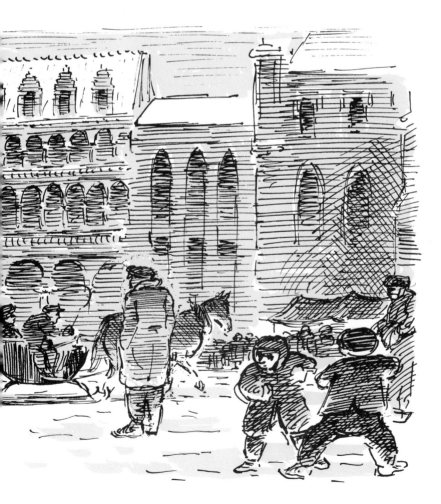

Now who started it I do not know. But I do know that my sister was a willing accomplice as I hacked off her curls. When we emerged into the light of the room there were wigs on the green indeed. My mother burst into tears; my youngest sister bellowed; my grandmother, dark in the face with anger, hauled me off to the bedroom and beat me. My shorn sister just looked smug.

Next day she was taken to the hairdresser and returned looking like a boy. My poor mother wept again at the sight of her and my sister looked even smugger than before. I was in bad odour for some time.

We returned to England by the night boat. The sea was rough. Our cabin seemed to be in the bowels of the ship and smelled of engine oil and I was sick.

East Bergholt with my Grandmamma

In the summer of 1906 my mother left for the Far East to join my father, taking my youngest sister Tetta with her. They were to be away for three years. The liner on which they were to travel called at Southampton before leaving England for good. So, soon after they had left East Bergholt, my grandmother took me and Betty by train to this port in order to say a final goodbye.

The liner was anchored some distance out in the Solent so we had to go out to it by tender. It was a brilliant day, the sun shone, there was a brisk wind and the sea was choppy. The liner, as we neared her, towered above us with her white superstructure gleaming in the sun. Flags were flying from mast and rigging and a band playing on deck added to the gaiety of the scene. We found my mother and Tetta on an afterdeck.

I can't remember feeling any sorrow at the time, I was too much absorbed by the novelty of it all. But when the last goodbye had been said and we had boarded the tender again and were on our way back, it was a different matter. By then the sun had gone in. It blew cold, the sea was rougher and I felt not only a little sick but very sad indeed.

My grandmother was the only woman I have ever known who actually went black in the face with rage. To be precise, its colour

was a deep mottled purple but the effect was black. The darkening of my grandmother's features intrigued us children. We knew what it portended and could at times take evasive action.

But why this elderly woman, who was normally gay, witty and affectionate, suffered from such an ungovernable temper is hard to say. She may have inherited it from her seaman father or it may have had a physical cause, such as high blood pressure from years in the tropics or much hardship as a younger woman.

My grandfather, Edward Irving, had been in the Colonial Service where he achieved the rank of Financial Secretary to the Malay States; a rank which, in spite of its resounding title, cut very little ice in those days. He was retired early from the service because of ill health and, of course, on a very small pension.

He and my grandmother and family first set up house at Falmouth. There, being a man of musical and literary tastes, he spent his leisure playing the viola (he was a member of a local amateur string quartet)

and reading. All this with rather more help from the bottle than was necessary. Alas I never knew him. From what I have heard from my mother he was a clever, gentle but ineffectual man. The sort of man I would have liked very much indeed.

Finally, finding Falmouth too expensive, they moved to Bruges where there was a colony of impoverished English gentry. For my grandfather the Anglican church, the library and the club. For the family an old house in a back street.

Stairs in old houses in Bruges are the same as in all old houses in the Netherlands, extremely steep, like ships' companion ways. To slip on them is hazard enough, to fall can be a disaster. It was a disaster in this case: my grandfather fell down them and broke his neck. My poor grandmother was left with almost no money and a family of seven.

There was little or no Irving money to help. My grandfather's male relatives being either civil servants or schoolmasters with families of their own had none to spare. Nor was there any Kirby money as the sea captain had sold his holdings in the Tanjong Paga docks at Singapore and had put the proceeds plus the rest of his capital into a ship's bottom. The ship sank.

My grandmother, like many of those formidable Victorian women, survived and managed to bring up her family in the way she thought proper to her class. But the going must have been hard and probably shortened her temper.

Now that my mother and youngest sister Tetta had left for Haiphong, I and my sister Betty settled down to live with my grandmother for the next three years.

Her rages affected us little. We treated them rather like acts of God, thunderstorms for instance. We sheltered from them if we could and if we couldn't, bowed to the inevitable. Like thunderstorms they blew up suddenly, burst into a torrent of scolding, then passed away as suddenly as they had arrived. At least once these storms were over there were no recriminations and there was never any harping back on past crimes.

In contrast to this she could be gay, affectionate and understanding, in many ways surprisingly tolerant. We were allowed much liberty to roam the countryside at our will.

She loved us and we in our turn loved her and were happy, though of course she never took the place of my mother in our affections.

I soon found, even at that early age, that she liked boys to be boys, and I could get away with much provided my naughtinesses were what she considered boyish ones. I am sure she would have been secretly delighted if I had been, like Tom Sawyer, up to every juvenile prank and devilry, and had been what she would have called a young 'limb'. I could never live up to this; I was something of a coward.

I do not remember who taught me to read, but I was certainly reading by the age of six when my mother left for the Far East and so too was my sister. Our first books were such juvenilia as *Little Black Sambo* and the first Beatrix Potter books. These were then, as they are today, enormous favourites. I am always angry now when I pick up a new edition of, shall we say, *Mrs Tiggy Winkle*, to see the illustrations which are but a pale pink travesty of those of the first edition. It was the delicate colour of the illustrations that we loved in these early books, as well as the precise and beautiful drawing of, to us, a familiar world, animals and all.

Later we were to progress to sterner stuff such as Charlotte Yonge's *The Dove in the Eagle's Nest* and George Macdonald's *At the Back of the North Wind*. And then to such teenage classics as Fenimore Cooper's *The Deerslayer*, Rolf Boldrewood's *Robbery under Arms* and *John Halifax, Gentleman* by Mrs Craik. But I was nine by then and my mother had returned to start us on Dickens, her favourite author.

By this time too I had become something of an artistic and literary snob. On a trip to London my uncle Alec took me to Harrods' book department and asked me to choose a book as a present. The final choice fell between a bound copy of the *Boy's Own Paper* and

a rhyming history of England illustrated by Heath Robinson. How much I longed for the former. But I chose the latter; I thought it was the right thing to do.

To go back to that first year we were alone with her — my grandmother, feeling that our education should be forwarded, hired a governess. The governess was a handsome young Irish woman with a determined-looking face and bold eyes. My grandmother called her, after she had left, a baggage, or was it a hussy?

Anyhow, through one long, hot summer, often with our lesson books at a table in the garden, she forwarded our general studies with some efficiency. It was only with music that she really failed. Betty and I, as part of our lessons in piano playing, would play duets. The piano was an upright. A metronome ticked away on top of it and beside us stood the governess. She held a round, black ebony ruler in her right hand. Every time we struck a wrong note, which was often, she would rap us over the knuckles. We were not, in consequence, forwarded.

She left us one day for reasons we did not know, though we realized that some great row was going on. I can dimly remember her departure, pink in the face, head thrown back and black eyes flashing. She did not say goodbye to us.

It was during this governess period that Uncle Alec arrived, to be followed soon after by Uncle Alan; both had come to spend some of their leave with us.

I had four uncles. Uncle Laurie, a rubber planter and a married man; Uncle George, a resident magistrate in the British North Borneo Company and married too. Then Uncle Alec, another planter, and Uncle Alan, a banker from Japan, both exceedingly gay young bachelors.

The name of Alec Irving is still remembered by old timers in Malaya. Also the tale of when, on one particularly festive evening, he burnt down the club house at Kuala Lumpur. The manager protested, 'You can't do this, Mr Irving,' but my uncle waved him off, saying airily, 'That's all right, I'll sign a chit for it.' Those were palmy days indeed.

Uncle Alan was very tall, rather stout, always extremely well dressed and very much the convivial young man about town. On leave he would inhabit bachelor chambers somewhere off Jermyn Street, would be seen often in the long bar of the Trocadero, was

welcomed by name by the head waiters of most of the smartest restaurants and would do the round of the shows. His cronies christened him the Gin King of Japan.

When with us they were lavish with their golden guineas. I usually came in for half a sovereign by way of a tip. For a small boy it was a marvellous coin, gold in colour, as small as a sixpence and heavy enough for ten. Its very weight in the hand gave it a potent feel like uranium. It felt precious and it was precious as it could buy so much.

With the coming of the uncles the establishment at The Gothics burgeoned. There was the dog cart in which one or other of the uncles would drive at a spanking pace the ten miles to Ipswich, at times taking us along with him. And then there was the governess cart in which the governess tried, in vain, to get some sort of pace out of the old pony. Betty and I had the exquisite pleasure of being allowed to drive it under supervision.

In the dining room the sideboard was loaded with assorted bottles and the sounds of whisky gurgling into glasses and the splash of soda were common. Strange phrases like 'What about a Stengah!' or

29

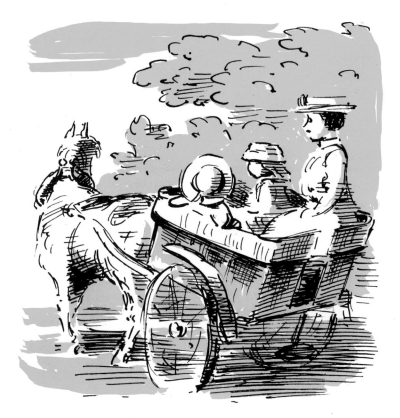

'Come and help me with my Barongs' were to be heard. There were parties too. Tea and tennis in the afternoons, dinner at night. Of course these were mostly for the grown-ups but at times we could participate and on these occasions met more of the neighbouring children than we normally had a chance to meet.

One flawless summer day we all went for a picnic, carrying food for both lunch and tea. Betty and I, the other children and the ladies of the party travelled in a horse-drawn wagonette, while the uncles followed in the dog-cart.

There was something splendid and noble about riding in the wagonette. It was so high that from it we could look over the hedges to the fields beyond; we felt like lords of the countryside surveying our domain. As we rode we sucked, in rather an unlordly fashion, enormous bull's eyes, called humbugs and were all very jolly. In fact we must have been a jolly sight. The girls were dressed in cotton

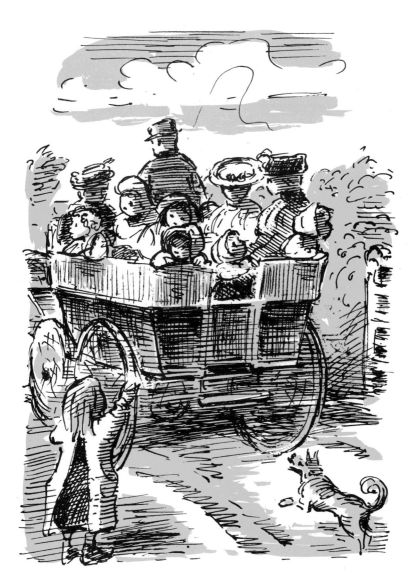

frocks and sunbonnets, the boys in sailor suits and big straw hats, while the ladies wore the big hats and high-necked blouses of the period.

Our destination was a clump of willows by the river Stour. There we unpacked our lunch. The lunch was a feast. Cold chicken, various salads and, supreme delight, strawberries and cream. To drink, lemonade for the children and champagne for the grown-ups.

After lunch I fell into the river and was pulled out by the uncles.

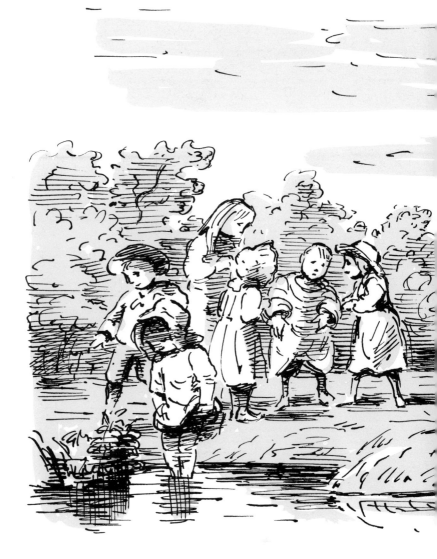

My wet clothes were taken off and I was dressed in one of my uncle's sweaters with the sleeves rolled up and the bottom pinned between my legs for decency's sake.

In 1907 it was still a horse-drawn world. There were the carriers' carts and the carts of various travelling salesmen; there were dog carts and pony traps, gigs, landaulettes, wagonettes, barouches and farm wagons. True, we saw a motor car from time to time, but not often, so that when a large open car driven by a chauffeur stopped at the gate of The Gothics it was, for the village, the cause of great excitement.

In the passenger seat was a stout lady, well veiled against the dust, and beside her a very large pekinese. Now the lady was a certain Mrs Chapman who at the time reigned supreme as the Mayor of Worthing. She was my grandmother's oldest and dearest friend and great was the rejoicing when they met. Like my grandmother she was stout, red in the face and talked nineteen to the dozen. In the speed and wit of her repartee she was a match even for my grandmother.

She was an ardent Catholic and, I have been told, a terror on the Bench. There is a story that once, at Petty Sessions, she had an Anglican clergyman before her on some minor motoring offence to

which he pleaded guilty. Having harangued him as if he were a hardened criminal, she sentenced him to a month in jail, only to be told by the Clerk to the Court that she didn't have the power to do this. The poor man retired shaken, with the loss of ten shillings as the appropriate fine.

At her home she kept many big pekinese like the one she had brought with her. It is rumoured that once she hunted the pekes in a pack, as if they were beagles, over the Sussex downs. I would not have put it past her.

Winter and summer

After the uncles had left and winter arrived, The Gothics settled down to its normal rhythm. Country walks were a plague to us, but my grandmother insisted on them. Long trudges, and how we hated them, down muddy lanes in biting east winds. All in a sad, cold countryside, and nowhere could be sadder and colder than East Anglia. The blue tits in the garden and even the spry young sparrows would cling to the pieces of bacon fat or coconut hung out for them. Our familiar robin perched on the kitchen window sill with his feathers fluffed out to make him look twice the size, and the poor boy who was both buttons and bootboy had chilblains. Lessons, of course, were now indoors and my grandmother's temper at our stupidities seemed to explode more frequently between four walls.

By now we knew many of the local people with families. There was a round of tea parties which my sister and I enjoyed, and then the occasional grand children's party which we enjoyed more in anticipation than in actuality.

The preparation for a grand party was a tremendous affair. For my sister much hair brushing, tying on of ribbons, donning of petticoat and party frock and trying on of party shoes to see the overall effect. Then wrapping up in shawls and coat and the putting on of

stout shoes for the journey to be changed again for party shoes on arrival. This all gave my sister great pleasure. I can see her now prinking about in front of the mirror admiring herself.

For me, being a boy, the preparations entailed a vigorous washing, a hard and prolonged hair brushing in an attempt to keep down the spike of hair that would stick up from my crown, and the putting on of fancy garments which I hated.

These grand parties, though looked forward to, would often prove something of an anticlimax for us. My sister and I were shy and would retire to some corner to look on, unless taken in hand by a grown-up and made to take part in such games as hunt the slipper or oranges and lemons.

The older boys looked very grand in Eton jackets, long trousers and white gloves. They danced the polka and even had the nerve to do it with girls other than their sisters. If the boys looked grand to me, the girls looked beautiful. Their calf-length frilly skirts would billow out and their long hair stream behind them as they went round and round in the dance.

While the dance was in progress we, the babies, looked on, but our minds were not on it. We thought in joyful anticipation of the supper to come and of the ice cream that we knew would accompany it. And what ice cream it was! It was made of real cream, real sugar and real fruit flavouring or chocolate. The manner of making it was this. The sweetened and flavoured cream was poured into a metal container which had a handle at one end. The container was then three quarters buried in a tub of broken ice and salt and then, by means of the handle, turned round and round. The result was an ice cream of such goodness that no modern shop-bought ice cream could compare with it.

The following summer was a hot one, with days of sunshine when one's arms were burnt by the sun and even one's shoulders under

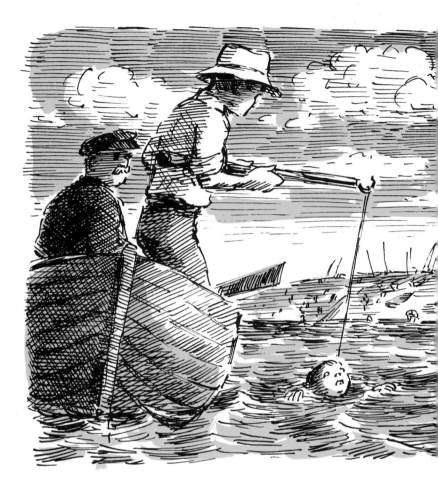

a thin shirt were reddened and sore. Three things happened to make it memorable for me.

First, I learnt to swim, or rather to paddle about and just keep my head above water. This satisfied my grandmother, who was always something of an optimist, that I was safe by the river and so she let me roam the water meadows and banks of the Stour on my own.

Second, my cousin Arthur Wilson, who was two years older than me, came to stay with us. He stayed a month. Poor Arthur, he was killed in Flanders in 1917.

Third, I took an active part in the harvest.

It was my uncle George, home on leave from his Residency at Lahat Datu, who taught me to swim. The method was simple and effective. So effective in fact that I do not remember more than one lesson, though memory being what it is there may have been more.

We went to Dovercourt, our nearest seaside resort. A boat and

boatman were hired and we rowed out into deep water. Then I was dangled in the water by a rope tied round my chest and attached to one end of a pole. Spurred on by my uncle I attempted some sort of breast stroke, until I discovered that the pole had been lowered and I was self-supporting. I sank with fright, but after a few more attempts I had the courage to go it alone.

Uncle George was a kindly man and, though we seldom saw him, was a favourite of ours. He was not so lavish with his golden guineas as were Alec and Alan, as he was a civil servant and had no part in the rubber bonanza. He was, however, a hero to us, with his tales of hunting crocodiles, elephants and that most dangerous of wild game the Timbadu or wild buffalo of British North Borneo.

My mother told us years later that once when staying at his Residency she saw from the verandah a number of elderly Dyaks. They were sitting dozing on the Residency lawn. She asked my uncle who

they were and he told her that they were his dear old prisoners. Their task was to cut the grass, but he was not going to act as warder and chivvy them to work; he was happy to see them idle away the morning hours.

When cousin Arthur came to stay my grandmother, who was probably pleased to get rid of two noisy boys, would, at the hint of fine weather, pack us off for the day. We went armed with sandwiches, fishing rods and tackle of the bamboo stick, line and hook variety. No fancy stuff like reels and landing nets. Our catches, naturally, were small. A few miniscule roach or a tiny eel or two out of the lock.

And then we would bathe. Our favourite bathing place was just downstream from the lock where the river ran shallow over a bed of clean gravel. Here we would splash about, two little naked boys like

two pink frogs, in the dappled shadows from the overhanging trees.

But, like most small boys of the period, we carried no watches, and like all small boys, we had no idea of time. At 10 o'clock we would eat the sandwiches meant for our midday meal. At lunch time we would return home ravenous. This was not popular. I can still see my grandmother on our arrival, her rising temper showing in her face. Sometimes we would hang about for what seemed an eternity, asking the occasional passer-by the time and not daring to go home until the time was right.

One day we had been bathing when Arthur, still naked, climbed a barbed wire fence. He slipped and fell, sustaining a long, deep and bloody scratch from hip to knee. A labourer who was working in the next field came up to inspect the damage. 'Ah! That's nasty that is. It ought to be cauterized with a red hot poker.'

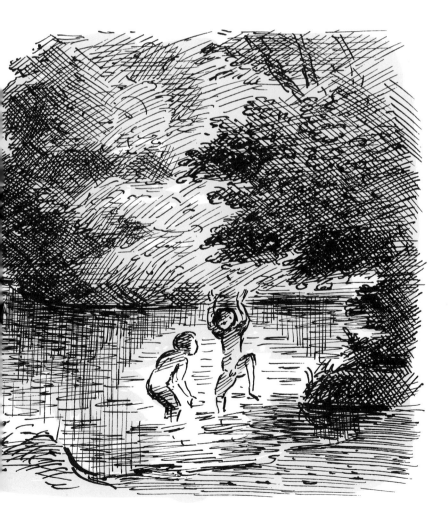

Arthur seemed unmoved at the threat but I, imagining the hot iron sizzling down the long wound, felt quite faint. Of course Arthur's leg was dressed when we got home. My grandmother, who was stern and competent and would stand no nonsense on occasions like this, dabbed the wound with neat black iodine and then covered it with lint and plaster. The iodine hurt poor Arthur considerably, though it was better than a red hot poker.

For me, perhaps the most memorable day of that summer was the day I went farther afield to take part in the harvesting of the wheat and to stay the night in the cottage owned by Nurse Spencer's parents.

All one long day the reaper and binder drawn by two horses went round and round the field leaving a diminishing area of standing corn in the centre. The women, many in old fashioned sunbonnets, stacked the bound sheaves into stooks, the wigwams of an earlier period, while we, the village boys, each armed with a stick, stood by hoping to clobber the rabbits as they bolted out of the island of corn that grew smaller all the time. The year before, I was told, a fox had slunk out of the corn, and we hoped to see one now. This time there

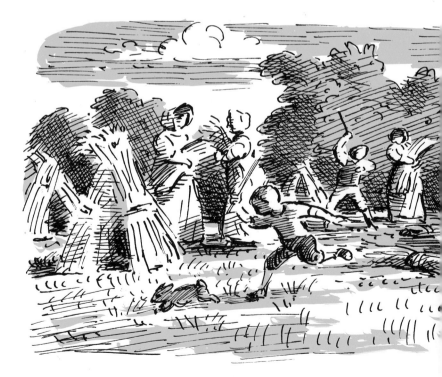

were no foxes but plenty of rabbits. To my bitter humiliation I missed every rabbit that ran past me. Many, however, were killed by the larger and more active boys and rabbit was on the menu in most cottages for some days to come.

The evening meal at the cottage in which I was to spend the night was laid, possibly for my benefit, in the front parlour. The parlour was tiny and the ceiling low, barely a man's height, and there was hardly room to squeeze round the table to get to one's seat. Half one wall was occupied by an upright piano, the top of which was draped in a brown woollen cloth edged with bobbles. One corner was filled by a grandfather clock tall enough to reach the ceiling. On the walls were framed photographs and two pictures in maple wood frames. These two pictures intrigued me greatly. They were painted, if that is the right word, in sands of different colours and depicted seaside scenes in the Isle of Wight. Where, I wondered, could one get such pale blue sand? What fun it would be to find it.

The mantel shelf was crowded with little pots and vases in biscuit coloured china. Each piece had printed on it the coat-of-arms of some seaside resort. Among them were coloured wine glasses, some

deep ruby red and others blue or green. Above the shelf hung a framed print of two figures in a close embrace. One was an angel and both, I presume, were floating up to heaven.

The meal was a typical Suffolk one. Suet pudding with gravy from the stewed rabbit which was to follow. Then the rabbit and vegetables, and to end, stewed apples and custard. Real custard made of eggs and milk.

My bed that night was in a room on the top floor. It was a feather bed and I found it intolerably hot. My sunburnt arms and shoulders were sore and irked me. The fleas came down from the thatch and bit me. I had in consequence a restless night. But it was not bad enough to spoil the memory of a marvellous day.

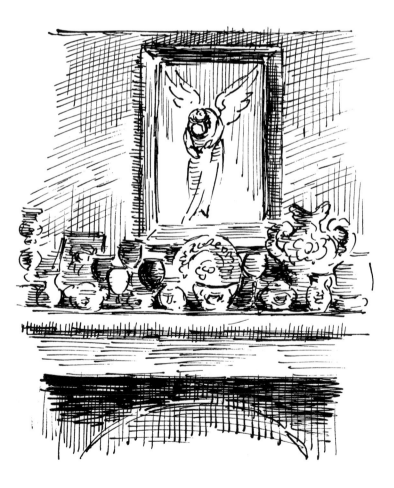

Mother's return and a memory of father

My mother returned to East Bergholt with my sister Tetta and a new baby, my brother David. Not long after my father was to join us.

Poor dears! Though they were good people, they were the most ill matched pair one could think of, and suffered much in consequence.

My mother was a pretty woman; she had a small head with soft fair hair, a fair skin and grey eyes. A very English type of beauty. She must have been a very pretty girl and to us she was beautiful.

Not only was she pretty, she was also very well educated. She had been given the type of education considered necessary in the upper middle class or, to be more precise, the professional class at the time. Her father, uncles and cousins were all university men. Her first cousin Miles had won the open Balliol at the age of sixteen. She both spoke and wrote French fluently and had a wide knowledge and real love of literature and painting. Though she studied painting as a young woman her talents, I feel, were more literary than visual. She had, however, no appreciation of music, being virtually tone deaf.

She was very proud of her Irving ancestry and spoke much of

the Irvings of Drum, the Irvings of Newton, Colonel Irving of Bonshore Castle, etc., etc. My sister Betty and I revolted against this eulogy, this putting up of the Irvings as superior beings. We did so partly because there was always the implication in our minds that being mere Ardizzones we belonged to 'a lesser breed' if not 'without the law'. We were later to discover our Kirby ancestry and to our delight found it much more interesting.

Many years later I came to realize that my mother was a very un-adaptable woman. She could not come to terms with new or different people or surroundings. Her tales of the French colons in Tonkin, and of their commonness and vulgarity, were an indication of this. She made few friends among them and must have been lonely when she was there. On the other hand all her love and interest was concentrated on her children. She adored babies.

Much later on, when grown up and having reached an age of understanding, it dawned on me that she must have been sexually cold.

How she came to marry my father is easily answered. My grandmother was the responsible party.

My father must have met my uncles in the Far East and then, on a visit to England, been introduced by one of them to the family in their house in Ealing. My grandmother, who was determined to marry off her last unmarried daughter, did the rest.

My father never understood this cold clever woman with, to him, a completely alien set of ideas. I still remember his bewilderment at my mother's horror when he suggested that all his sons in turn should be apprenticed to cabinet makers. He considered that as, in his view, we could neither write a copperplate hand, spell well, nor do simple arithmetic, it would be a suitable career for us. In fact it was not such a bad idea as it sounded to my mother.

Early photographs of my father show him as a tall, fair man with a blonde moustache and inclined to stoutness. His eyes were blue. He was proud to be a north Italian and was indignant when somebody once suggested that he might be related to a Sicilian family of the same name. 'What, those wogs,' he said, or words to that effect, 'they are nothing to do with us.' In fact Ardizzone is a name found in Milan and the north of Italy and in its French form of Ardissone in Nice and other resorts along the coast.

His father, my paternal grandfather, was a man who had come down in the world. At one time he owned a steamship line or at least one steamship trading from the port of Bari. He went bankrupt and, with his wife's money, bought a *caique* and continued to trade the Mediterranean, finally installing his family in the Algerian town of Bône where my father was born, the youngest of the family and a posthumous child. He was christened Auguste.

As a young man he joined the Eastern Telegraph Co. in Algiers. Later he was transferred to the Eastern Extension Telegraph Co.

and sent to the Far East where he spent the rest of his working life. Starting in the Philippines, he saw service in China, Indo China, Malaya, North Borneo and finally returned to the Philippines where he spent the last years before his retirement as manager of the Cable Station at Manila.

In many ways he was a remarkable man. He was fanatically honest and so punctilious about his debts that they had to be paid up at once. He could not bear to owe anything even for a day. This of course caused trouble at home as my mother was extravagant and dilatory about settling her bills.

Then he was a magnificent linguist. French was his first language, but he both wrote and conversed in Spanish and English equally well. German and Italian came fourth and fifth in order of merit. He had a working knowledge of Russian and was reputed to have known at least six Chinese dialects. He used to say he could learn a language in three months and I feel sure this was no idle boast. His method

was first to learn the grammar by heart and then set out to speak it. I tried this method and failed. Learning the grammar by heart was too much for me.

I think his success in languages was due to a very fine and receptive ear. For instance, on returning to England from the Philippines he would speak at first with a Spanish-American accent, but within a fortnight his pronunciation was flawless.

He certainly had an ear for music but only knew and loved the more sugary Italian operas. He had no knowledge or feeling for literature and the arts. In fact I never saw him read a book in any language except some manual on electricity. As for pictures, he could only understand the most conventionally representational ones. Sometimes when I had made a drawing and taken great pains to make it lifelike and understandable he would lean over my board and say in a muffled voice, 'Ted, my boy, what does it mean?' I was always hurt.

My father had had many adventures though he would rarely speak of them. He had seen the fall of Port Arthur from the Japanese side in the Sino-Japanese war and was very scornful of the Russian officers whose rooms were found to contain silks and satins, scent, ladies' slippers and bottles of champagne. He had been involved in a late Boxer rising and had seen the plague cities of China where men died in the streets. But perhaps his greatest adventure was during the Spanish-American war in the Philippines.

I have at home a magnificent decoration in gold and enamel which had been awarded to him for his services to Spain in this war. It is the Military Medal 1st Class, with the distinctive white, whatever that may mean, and is equivalent to the British V.C. I know that he was given special privileges when he was in Spain.

The war was a particularly beastly one of the guerilla type. The Philippinos, backed by American arms, were revolting against their Spanish masters. There was, as is usual in this type of war, senseless slaughter and atrocities on both sides.

At the time my father was in charge of a small relay cable station situated in a beleaguered fort and as far as I can make out, he more or less took charge of the defence, going round the walls at night to keep the sentries up to the mark. What he could not bear, but could not prevent, was the appalling slaughter of prisoners which took place daily in front of his office windows.

Another of his activities was to act as messenger. Nearly naked, smeared with black oil, he would creep through the enemy lines to warn the inhabitants of outlying farmhouses of guerilla movements. Once he swam out under fire, he was a strong swimmer, to a Spanish warship. He carried important despatches. But of all this he would say little or nothing.

As well as being a fine swimmer he was a crack tennis player and was always a popular member of the European community where-

ever he stayed. Alas, poor man, the only person he could not get on with was his wife.

With my mother back, I and my two sisters were soon immersed in many activities. Apart from walks in fine weather and the many games we played, we wrote, drew and busied ourselves writing poems which we sent into poetry competitions run by a children's magazine. To my astonishment I won a prize in one of these. This I found was not popular. It was as if I had poached on Betty's preserves for she was considered the literary member of the family.

In the afternoons my mother would lie with her feet up on the drawing room sofa and read to us. Her favourite reading was from Dickens and his work was a favourite of ours to listen to. I think my mother must have judiciously cut out large chunks from the text to speed the action. Certainly we were never bored by these readings, quite the reverse. We adored them and adored most of all the sentimental bits. I doubt if any of us, my mother included, were quite dry-eyed at the death of little Paul Dombey.

One notable afternoon the three of us performed a one-act drama composed by Betty in so-called blank verse. Our costumes were made of old sheets, the stage was one end of the drawing room and the audience my mother, my grandmother and the baby. At the high point of the drama, as I was about to stab Betty with a wooden sword and Betty gave an unearthly shriek, there was an appalling crash. My mother's companion, poor Dora, who suffered from the *petit mal*, was watching us from the stairs. At this precise moment she had a fit and plummeted down to the hall below. A silence followed which seemed to last an eternity, then we all rushed into the hall to find Dora on the floor, shaken but not badly hurt. It was, however, the end of the play.

Among our friends at the time were Mr and Mrs Withycombe and their three daughters who were about the same age as my sisters and myself. The Withycombes were the intellectual, or to be more precise the 'avant garde', family of the neighbourhood.

Withycombe was a painter and a good one, whose work never had the recognition it deserved. His wife was clever and charming. Both were Fabian socialists, great lovers of the countryside and believers in the virtue of the simple life.

We children always enjoyed our visits to their farmhouse. We found a sense of freedom and an atmosphere very different from that of the homes of our more conventional neighbours.

We rarely left the Withycombes without some new idea for our childish minds to feed on. Betty and I, for example, were great lovers of Kipling's verse, until one day Mrs Withycombe told us in all seriousness that Kipling was only a versifier, making this new word sound to us very low and degrading, and was also a Jingoist,

another new and splendid word. We, being horrid little literary snobs, decided there and then to despise Kipling.

By now our days at East Bergholt were numbered. I was big enough to wear a Norfolk jacket and knickerbockers and my mother, realizing that the time for me to start a more formal education was overdue, decided to move the family to Ipswich where I was to go as a day boy to the junior section of Ipswich Grammar School.

However, before The Gothics was packed up and the final good-byes said, we were to attend one magnificent party, a children's fancy-dress ball held in the big house of a wealthy neighbour.

Mother, who was a very fine and imaginative dressmaker, dressed me and my two sisters in Elizabethan style costumes. These were so well made and so historically accurate, ruffs, puffed sleeves and breeches for me, slashes and all, that neither she nor we got credit for it. Most of the guests thought that they had been hired from a costumier in London.

The arrival at the party was most exciting. The procession of carriages coming to the door. The crowded gentlemen's cloakroom where the boys changed their shoes and donned white gloves. The

chatter and squeak from the girls' room over the way and the sound of the violins from the ballroom beyond.

Though no party for us, being the shy ones, was a thing of unalloyed joy, this one was enjoyable enough. It ended in a splendid gallop.

So, hot, tired, full of ice cream and delicious food and long after bedtime, we trotted happily home in the hired carriage to tell mother all about it.

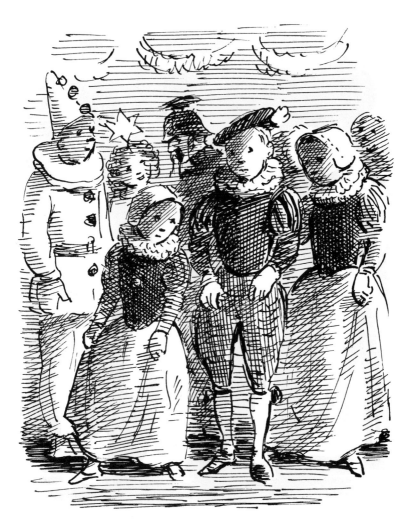

Ipswich

Three great fears overshadowed my stay in Ipswich. The first was the fear of a ferocious grocer's boy; the second the fear of lessons in school; and the third of the schoolboys themselves. The last two lasted longer than the first. In fact they lasted most of the time I was there. It was not a happy time.

One day fairly soon after our arrival, I got off a tram and was half way across the intervening piece of road to the pavement when I was run into by a boy on a bicycle with a basket of eggs in front. I was bowled over; the boy and the bicycle went over and the eggs were broken. It was a horrid smash and I, rather dazed and a little bruised, got to my feet and crept home.

The next day, to my surprise, this same boy turned up at our house, a semi-detached affair with the rather grandiose name of Gainsborough. He was a tall, skinny boy with red hair, a bulbous nose and two little blue eyes placed rather close together. His jacket was far too small for him and his red wrists and large red hands stuck out far beyond the cuffs. He demanded money for the broken

eggs from my mother, who indignantly turned him away. But as he was about to go out of the garden gate, he spun round and looked at me with an expression of such malevolence and ferocity and cried out with such a hoarse and common voice that he would bash me to bits if he ever caught me, that I was afraid.

My mother pooh-poohed my fears, but for months after that I left the house on my own in fear and trembling. At the garden gate I would peer left and right before leaving in case he was in our street. I approached every corner with apprehension. And if I caught sight of him when away from home, I would make a long detour to avoid him. This caused endless trouble. If I saw him on the way to school I would arrive late, or if on the way back from school I would be late for tea and if on an errand for my mother I would be scolded for taking so long over it.

The fear of lessons started on my first day at the junior school. The room was large and must have seated about forty to fifty boys. The rear desks were slightly raised so that I, sitting at the back among

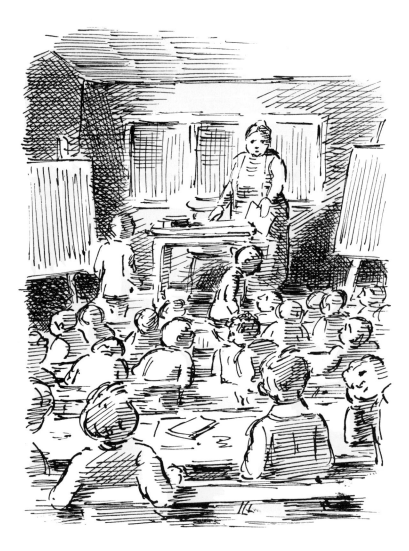

the new boys, could look down on my seniors in front. Our mistress,
stout Miss Hunt, sat against the opposite wall with a table in front
of her and flanked by blackboards and other scholarly impedimenta.

Many, many years later I have talked to men who had once been
her pupils. They all referred to her with affection as dear old Miss
Hunt. To me she was not dear old Miss Hunt at all, but an ogress.
I felt she disliked me, and if this was true and she really did dislike
me, I cannot blame her. I was, I think, an unlikable boy. I was large
for my age and rather fat. Added to this I was timid, totally lacking
in charm and so stupid at my lessons that Miss Hunt must have
thought me a moron.

Now, I had arrived at the school as well equipped in learning as any of the other new boys. My ability to read, write, do simple arithmetic was above average, and the same could be said of my knowledge of the elements of history and geography. But in the classroom, surrounded by boys, with a stern looking mistress ahead, a sort of shutter came down in my mind. I could not do the simplest sum; I could not think.

This state of affairs, instead of improving, became worse as the weeks went by. The number of marks I earned became less and less until one day in desperation I did the unforgivable thing. Each boy was given a small notebook in which he had to enter the marks he had gained for every lesson during the week, and then first thing on Monday morning of the next week he had to stand up and read out these marks to the class. I cheated and read out a list of marks that sounded more reasonable, and was immediately given away by my classmates with their, 'Oh! Oh!; Oh Miss! He couldn't, Miss!', etc., etc. After class, I, a small boy with a pink face and head hanging low, was lead by Miss Hunt to her study and caned on the hands.

It was a just punishment and one that I had earned by my stupidity, but it hurt considerably. I still have a vivid memory of how, with tear-filled eyes, I rubbed my hands against the seat of my pants and wondered if the smart would ever go.

My progress when I moved up to the senior school was little better, though I must have learned something to get there. I still remained a dullard, always at the bottom of the class and in a state

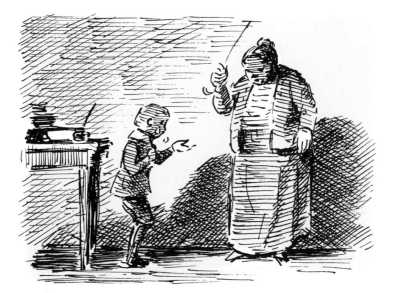

of apathy. I had given up making an effort. My form master tried the effect of a beating or two in the hope they would force me to work, but this method also failed.

My mother, worried by my bad reports, arranged for me to have extra lessons during the holidays. My teacher was a young clergyman named De Candole. These lessons helped me greatly and I discovered under his gentle tuition that I was not a fool. Admittedly I did not do all that better when I returned to school, but I never went back to being the hopeless little sluggard I was before. I owe De Candole a great deal.

My fear of my fellow school boys was very real. I was born to be teased and bullied. In fact because I was nervous and stupid I almost brought it on myself by invariably saying the wrong thing.

How I hated the school corridors crowded with boys pushing, shoving and shouting. The noise and scrimmage bemused me. I was always afraid of being set on, and was glad to get away into the quiet of the classroom.

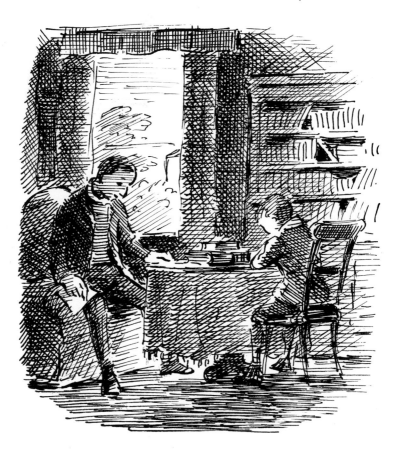

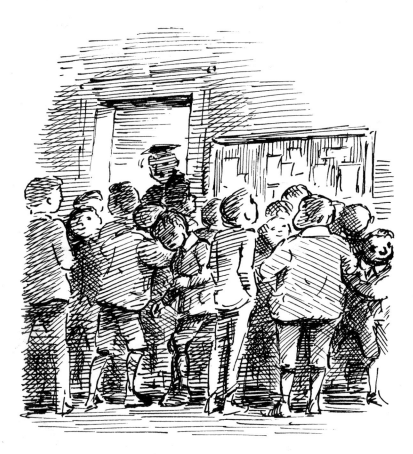

Journeys home from school could often be a nightmare. The quick way was through the park and in the half dark of winter afternoons I would scud from tree to tree in an attempt to avoid my tormentors. If caught I was subjected to every sort of humiliation. My cap was snatched off my head and thrown high into the bushes. If I tried to reach for it my satchel was thrown away in another direction. I was pushed this way and that, knocked down and muddied. But in my early days at the junior school my troubles did not even end there. Once through the park I had to face the danger of meeting the ferocious grocer's boy.

My humiliation reached a climax when one afternoon I was dragged to the seclusion of some bushes and held firmly by a gang of small boys while the chief bully undid my fly buttons, pulled out my poor little penis and applied the hot ends of spent matches to the tip of it.

After this I had the wisdom to avoid the park and take the longer

route through the streets. I could, of course, still be humiliated in these streets, but not to the same degree.

My mother knew or guessed that I was being bullied, though I was never able to tell her the full extent of what I had to undergo. I neither had the words to do so, nor would my pride let me. She decided however that I should have lessons in the noble art of self-defence, so that I would be able to stick up for myself. On Saturday afternoons I was sent to a gymnasium in the town to be taught the rudiments of boxing and jujitsu. The lessons were of no help to me. I was involved in a battle in which there were no rules and one in which my opponents were many. My need was for courage and fighting spirit rather than the ability to hit another little boy in the eye.

At last my mother complained to the Headmaster, the great Dr

Watson himself. The meeting took place outside the school and after school hours. I can see them now as they paced up the pavement solemnly side by side. I followed sheepishly a little way behind. I can still hear the Doctor's great booming voice as he spoke in answer to my mother's treble. His last words were, 'Madam! It is six of one and half a dozen of the other.' I knew then that all hope was gone.

To be truthful, the years I spent in Ipswich were not entirely unhappy. There were Saturdays and Sundays and long school holidays. Even at school there were many days which were pleasant enough, days when I was not teased and when lessons went comparatively well.

Certain happy memories of these days stand out for me like islands in a sea of forgotten things. The day my father took me to Colchester. We visited the castle and inspected the dungeons, which filled me

with a horrid fascination. We looked through a hole in a wall into a tiny, dark cell, windowless and doorless, where some poor prisoners had been confined for life in utter darkness. We saw instruments of torture, the rack, the thumb screw, the iron maiden and, what moved me most, the deep indentation in the shape of a man in one of the stone walls. The keeper explained to us that it had been made by the bodies of men being squashed slowly to death against the wall by some great instrument.

Coming up for light and air, we went to the pub. Father, forgetting the English licensing laws, tried to take me in with him but, this being forbidden, I sat on the step drinking my lemonade, as my own children have done many years later, while he then and I in time to come, drank a pint of beer. We got on well, father and son, or rather little son, as I was still only nine years old.

I remember nothing more of him at this time. He must, of course, have stayed with us, but it may not have been for long. I have a half memory of some great disagreement between him and mother which may explain why.

At some time or other I must have joined the Boy Scouts. Of our drill hall, our meetings, the various rigmaroles we went in for, I have no memory. But one scene that lasted only a few moments remains with me still.

We were marching through a poor quarter of the town. Why we were doing so and on what errand I have forgotten. Our Scoutmaster, a young man, was dressed in regulation uniform and so also were the first four files that followed him. Each carried the appropriate staff and each was decorated with many badges. We that came after were a motley crowd. A few had scout hats, but most wore school caps. The rest of our clothing was most unorthodox: a variety of different coloured jerseys, shorts and stockings. Even the scout scarf was often lacking. Those that carried a staff handled it self-consciously and would from time to time trip over it. All of us seemed to be out of step.

Our route lay alongside a spiked iron railing which formed the fourth side of a square of dilapidated houses. On the other side of the railing a terrible fight was taking place. A man had a woman by the throat and was pressing her head backwards over the railings towards us.

He was a fearful looking creature, very tall and dressed only in ragged shirt and trousers. His head was a great, hairless dome with underneath a wild, ravaged face, haggard and unshaven, like some ghastly drunk out of Hogarth's 'Gin Alley'.

The woman was large and stout and very strong. I was fascinated by the arch of her wide body as she was bent backwards over the spikes and by the indentations the spikes made in the broad expanse of flesh. I was fascinated too by the great swelling biceps of her bare arms as she, in her turn, clutched her assailant's throat. They fought

almost silently but with concentrated ferocity. The only sound was
the sound of heavy breathing and the occasional grunt. A perfect
subject for Daumier.

We boys stared goggle-eyed at this scene until our master turned
and in a prissy voice said, 'Eyes front, boys. Remember never to
interfere between man and wife.' Obediently, eyes 'fronted', we
marched on, though I could not resist an occasional backward glance.
It looked like murder.

Ipswich in 1910 was a rough, tough town. One did not venture
into the populous parts on a Saturday night because of the drunks
who were often to be found lying insensible in the gutter. In 1910
the Lloyd George 'Two acres and a cow' election, so called because
of his proposal to create a large system of small holdings, was bitterly
contested. The shutters were up in the main streets and the town
looked as if it was in a state of siege.

Even in the daytime one could, in the poorer areas of the town,

see much drunkenness. I, as a small boy, was privileged to witness a magnificent example of this.

One day, scudding along the street, I was attracted by the shrill noise of shrieks and falsetto curses, and turning the corner I saw on the opposite pavement two women outside a public house. They fought each other clawing, scratching and shrieking like tiger cats. Both had long raven-black hair which tumbled down over their backs and shoulders. Both wore nothing but a thin white nightdress and both were barefooted as if they had just got out of bed. At one moment the stouter of the two dragged her opponent along the pavement by her hair. The next moment the thin one retaliated by tearing away the front of the other's night gown, leaving her heavy breasts and most of her belly exposed.

Over the engraved glass which covered the lower half of the public bar window the heads of men could be seen watching them. The only other spectators were a small boy and a tiny, ragged girl. The boy held the little girl by the hand and stood by a lamp post a

short way up the pavement. They were motionless. Nobody attempted to interfere.

This scene has always haunted me and many times in years since I have tried to draw it from memory and put down on paper the wild movement of the fighting women in the still setting of the street. I am sure it was a formative moment in my career as an artist.

1911 was for most of us a year of many happenings. During this year we moved again, to a small detached house in a suburb. Here my youngest brother Michael was born, causing the usual domestic upheaval occasioned by the arrival of a new baby.

Another arrival was that of my cousin Mary. Her mother, my Aunt Nancy, had died and Mary was for the time being to be given a home by us. She was about the same age as my brother David. Both were the prettiest little children. They were very fair with blue eyes and the palest of pale gold hair. David's was curly while Mary's was soft and straight. My mother adored them as she adored all babies. They were her favourites. Mary was to grow up to be a best

selling novelist and writer of detective stories under the pen name of Christianna Brand.

The death of the boy in the sand pit and the scandal and gossip that followed caused yet another excitement. The boy's body had been found after some days buried under a fall of sand from the pit edge. There had, however, been a witness to this fatal fall, another boy, somewhat older than the victim. This other boy was, like me, a pupil at the Grammar School, though no friend of mine. He was a poor halfwitted oafish chap, who was either too stupid or too frightened, thinking he was in some way to blame, to call for help, but had just sloped away and said nothing.

Of course the police, by their enquiries, discovered all. The tongues of little boys wagged, parents spoke about it in whispers and the local press attacked both council and contractors for allowing a dangerous pit to exist — a pit I had often played in myself.

The high point of the year was Henley Regatta. My grandmother was living at the time in a house at Shiplake near Henley-on-Thames and I was invited to stay with her for regatta week. The house

seemed very large and luxurious compared with our small house in Ipswich. It stood in its own grounds complete with tennis court. Both Uncle Alec and Uncle Alan were on leave and, with their two girl friends, were staying with her too. The girls to me looked wonderfully pretty, and all four were very gay and smart.

However the first morning of my stay was clouded by a tremendous display of temper on my grandmother's part. My uncles, their girl friends and I were sitting at a late breakfast in the dining room when Grandmamma came in, slamming the door behind her. She wore a dressing-gown, and knowing by the darkening of her face that a storm was due and that she was at her most formidable when in her dressing gown, I was prepared for the worst. And the worst was bad indeed. She harangued the company with an incisive ferocity which must have startled the poor girls. I, feeling that all this had nothing to do with me, hid behind the curtains of the bay window.

My uncles tried to calm her and then suggested that the young ladies might leave. But my grandmother would have none of it. She stood with a mighty arm stretched out at a right angle to bar the door and insisted that all should stay to hear her out.

I still don't know what the row was about, but my grandmother, having said her piece, was angry enough to stalk out of the dining room and into the drawing room where, still black in the face with rage, she leant so heavily on the mantelshelf that the whole contraption came away from the wall and fell with a crash to the ground. The result was that Chinese vases, decorated plates, netsuke, elephants carved in ivory, Borneo brasses and other impedimenta from the East lay in ruins at her feet.

But, as I have said before, my grandmother's rages were short lived. In no time we were on the river. Two punts had been commissioned and were well stocked with champagne, foie gras sandwiches and other delicacies. The girl friends looked doubly pretty

in their large hats and party frocks. The uncles were dressed up to the nines, Uncle Alan, who had grown a little stouter since I last saw him, in particular. He wore a high, stiff collar and a club tie with his white shirt. His white flannel trousers were immaculate and so were his buckskin shoes. His blazer with its brass buttons lay in the well of the punt. On his head he wore a white straw boater.

My grandmother, her anger forgotten, was in high good humour and all was gaiety, until we were rammed by a passing punt.

Alan, who was poling us upstream at the time, was taken by surprise at the shock of the collision and fell overboard. For one horrifying moment all we saw of him was his straw hat floating gently

away. However, he soon surfaced and was hurried ashore. It was not
long before he was back with us, looking as immaculate as ever, to
enjoy strawberries and cream at Phyllis Court.

Three more halcyon days were to follow this before I was sent
home to the more plebian life of school and a provincial town.

My last year at Ipswich was considerably sweetened by the arrival
of my cousin Arthur. He joined the Grammar School and being
older and tougher afforded me some sort of protection. He was also
an adventuresome boy. Under his lead we would explore the docks
together, something that I would have been a little scared to do alone.

The docks at that time were always full of sailing barges with their

great red sails, and small coastal steamers that had come up the river Orwell from the sea.

They arrived to discharge such cargo as cement, china clay and coal and left laden with farm machinery from our local factory and wheat from the Suffolk fields. Each barge was manned by a barge master and a boy in his late teens. The boys were often left on board while the master was away on shore and we got to know a number of them and were given the freedom of their craft.

We would also climb on board the steamers. On some the sailor left in charge was a kindly man or just wished to relieve the tedium by showing us round his ship, while his mates were in the local pubs. Then we would visit bridge and engine room, explore the holds or stand on deck to watch the stevedores at work. More often than not we would be chased off, which would add a spice of adventure to our day.

These days in the docks were to bear fruit for me in the years to come, for it was the nostalgic evocation of them that formed the basis of my books about Little Tim.

My mother moved the family to the small town of Wokingham and set up a new house there. Her reason was not apparent but perhaps she disliked Ipswich as much as I did. She left me behind for a month or two to finish the summer term at the Grammar School. I joined cousin Arthur and we were both boarded with Miss Willis, an elderly spinster who lived in a farmhouse near a small village some eight miles out of Ipswich. From Monday to Friday Arthur and I bicycled the eight miles into school and back again.

The route ran through pretty, rolling country. The soil was sandy and the road not tarmac'd. It was bordered sparsely by old oak and ash trees which grow at their best in the Suffolk countryside. Often we would put up a brood of partridges, the chicks running ahead while the mother bird trailed behind pretending to have a broken wing. A large pond was a favourite stopping place. Green with duckweed at our feet, there was clear, deep water beyond and then a bank of tall reeds where we felt certain some monstrous pike lay hidden only waiting to take the right bait.

Once when standing on my pedals and coasting down hill, the chain broke and I took a tremendous purler over the handlebars. I fell face down on the gravel road and took all the skin off my nose.

Arthur insisted that I should bathe the wound in this weedy, stagnant pond, in case the sight of my bloody and dirty face should upset Miss Willis. I did so, and fortunately there was no harm in it. The graze healed beautifully and the scab was so extensive that I might have had a chocolate nose. Indeed for days to come I had the exquisite pleasure of picking at the scab and eating the bits that came away.

The house we stayed in was of two storeys. It was old and surrounded by tall trees, and was built in the usual mixture of Suffolk styles: Tudor brick, Jacobean half timbering and pargetted here and there in the East Anglian tradition, though little of this could be seen as the façade was covered with Virginia creeper.

The parlour, which was the main room, was square in shape. It had a very low ceiling and because of the trees outside and the creeper which obscured half of the one window it was dark and cool in hot weather. The wallpaper was dark brown; the cloth on the big

table in the centre of the room was brown and the chairs were up-
holstered in the deepest shiny brown leather, giving the effect, on
coming in, of entering a shadowy brown world.

At high tea the round table was covered with a white cloth. The
first course was often a dish of winkles, which we would eat with
the help of a pin. Miss Willis was very partial to winkles so Arthur
and I would bring them back from Ipswich for her. I liked them too
and I too am partial to them to this day. The winkles were followed
by lightly-boiled new-laid eggs and bread and butter and strawberry
jam. All this was washed down with strong sweetened tea the colour
of red mahogany. I can't remember a meal I enjoyed more.

At the back of the house was a great old barn, attached to the
rafters of which were many swallows' nests. If you climbed a ladder
you could look into the nests and see the eggs.

Beside the house was a small pond on which Arthur and I fought
a naval battle against the local youth. Between the two of us we had

concocted a raft, which we boarded and pushed into the centre of the pond. Then with mud and stones which we had loaded onto our craft, we pelted the passing village boys. Of course they soon retaliated and in no time we were engaged in a battle royal. It only ended when Miss Willis, alarmed by the noise, and a man or two from the village, came to put a stop to it. In the meantime we felt like twin Nelsons engaging the blockships and shore batteries at Copenhagen.

Wokingham

Wokingham in 1912 was a small, bustling town on the main road to Reading and the west. It had its quota of narrow winding streets, its one very broad one, its Victorian town hall and many handsome red brick Georgian houses. It is very much the same today, except that a Woolworths and other large departmental stores have taken the place of many small shops, and cars instead of horse-drawn carts and vans now crowd the streets.

Our first house in the town, which we named Newton in honour of our Scottish ancestors, was part of a row of early Georgian houses facing the ugly red brick Catholic church. It was extremely narrow, being only one small room and a passage thick, but it went back and back to older parts where rough-hewn timbers of the Jacobean period supported the ceilings in contrast to the moulded plaster and elegant wood panelling of the small front parlour.

The garden was long and narrow too with a high brick wall down one side. Plums and greengages ripened against this wall, the best

greengages I have ever eaten. A vast Blenheim apple tree shadowed the outhouse and scullery and cast its shade on a chicken run in which a few hens scratched about. Beyond this was a profusion of dwarf pear and apple trees, and gooseberry bushes and raspberry canes.

The house and garden together made a small world, narrow, deep and shadowy. A world which enchanted me.

However I was soon to go to boarding school, so my memories of this house and of the whole of my stay in Wokingham exist as a series of vignettes between long periods at school.

Of these vignettes the first concerns the church. The church being just across the road from us, I was soon enlisted as an altar boy — a task I was well qualified to perform having been trained by the nuns in East Bergholt.

One Sunday morning, when robing for Mass, our elderly and very absent-minded parish priest had quite forgotten to put on his cas-

sock and was about to go to the altar with his legs encased in black trousers, showing under cope and surplice. A most unseemly sight. The three other acolytes were holding their hands over their mouths and simply bursting with suppressed laughter. By signs they forbade me, being the youngest, to give the game away.

But this was too much for me. I was at the time a pious child and could not bear to allow what seemed to me to be almost a sacrilege to take place. So I plucked up enough moral courage to stop the priest as he was about to leave the vestry and point out to him the deficiency in his attire. After Mass the other boys picked me up by the arms and legs and bumped me on the floor for spoiling the fun. My reward came, however, the following Sunday when the kindly old priest presented me with a handsome rosary which had been blessed by the Pope.

Another little picture survives. It is of Betty and I, with muted giggles, laying a trail of corn from the chicken run at the back of the

house, through scullery and kitchen and down the long, dark passages, and so enticing the hens into the drawing room where my mother was giving a tea party. She was quite naturally furious.

But memories, or as I prefer to think of them, pictures, begin to crowd in on me here. For instance, there was the affair of the Paris hats. My grandmother in an expansive mood had been to Paris and had returned with hats for herself, my mother and my sisters. Not only this, she whisked us all off to Malvern for a short holiday.

The hats were all enormous and very ornate. My mother's looked like a shallow, inverted bowl. It was white and black and crowned with white frills. She, I think, disliked it. The girls' hats were large gold confections worn squarely on the tops of their heads. I know

they disliked theirs. How they groaned when they had to wear them, but to wear them was a must.

What a sight they made on church parade! Grandmamma well-corsetted and dressed in black from the crown of her great hat, dominated by ostrich feathers, to the tips of her toes, led the way. Mamma followed, surmounted with frills and wearing a narrow-waisted lacy blouse and hobbled skirt, while the girls, dressed in calf-length frilly frocks and white gloves and wearing their hair in pigtails under their golden hats, straggled sheepishly behind.

There had been a drought that year and the steep slopes of the Malvern hills were covered with dry, burnt grass. So slippery were these slopes that we were able to toboggan down them on tin tea trays, which became almost too hot to sit on in the process.

On one particularly sultry afternoon my grandmother and I paced Malvern churchyard while she examined me on my reading. I was supposed to have read *Ivanhoe* and had foolishly said I had done so. But I could not read the works of Walter Scott then any more than I can now. Relentlessly the questions came as we moved from tombstone to tombstone. Lamentable were my silences or bad guesses, showing that I knew little or nothing of the book. And dark was the

look on my grandmother's face. At home that evening I was to feel for the last time the sting of the hairbrush wielded by her strong right arm.

Back in Wokingham I was present at a very bitter quarrel between my parents. Unfortunately I was dragged into this quarrel by my mother and, in the nature of things, I was on her side. This involvement caused in me a mixed sensation of fear, unhappiness and guilt. The guilt because I realized that my loyalty to mother was not complete. Even to my childish mind much of what she had said was unforgivable, and I was made aware for the first time of the appalling power of an angry woman's tongue. To this day it makes me unhappy to think of it.

Apart from this, my memories of Wokingham were mostly happy ones. Many were concerned with Tommy Kimber who became my best friend and was to remain so for many years.

I was first attracted to Tommy because he had two toy railway engines worked by real steam, some rolling stock and a length of railway line which was set up round the lawn of his parents' house.

Once steam was up, how merrily those engines puffed and rattled round the track, dashing through long tunnels made of stones and turf and sometimes getting involved in fearful accidents improvised by us, when they would lie steaming and panting on their sides just like the real thing.

Soon our joint enterprises took us farther afield. We would bicycle all over the countryside, linger on railway bridges trying to spit down the funnels of the engines as they roared beneath us, or spend days fishing on the river Lodden.

Our fishing days followed a pattern. Armed with sandwiches for lunch, our first port of call was the Baker's and Confectioner's. Here we would each buy a bag of doughnuts, full of jam and hot from the oven. Then two large slabs of Sharp's creamy toffee and two bottles of lemonade with marbles in their necks as stoppers. You had to press these marbles down with the end of a pencil before you could get at the lemonade. We consumed the doughnuts on the spot, munched toffee as we cycled along and reserved the lemonade to drink with our sandwiches.

Unless it rained or a cow stood on our sandwiches and made them uneatable, we would stay out till tea time.

The fish we caught were small, rarely more than a few ounces in weight, and the catches were few and far between. Consequently we often tired of sitting and watching our floats and would abandon our rods and tackle to race the fields, climb trees, make harbours and dams along the river bank or bathe if we found a suitable place.

Once we caught a moorhen and planned to bring its body back in triumph. We tried to kill it by wringing its neck. I had first go and failed, then Tommy tried and failed too: the longer we went on the more awful we felt about it. Yet we had to go on. We could not leave the wretched bird to die slowly with a half wrung neck. Then in desperation we tried to drown it, but it seemed to refuse to die. Finally in despair we flung its body away among the reeds, hoping it was now really dead but none too certain all the same. We left for home weighed down with such a load of guilt and horror that we might have been the worst of murderers.

With Tommy's air gun it was a different matter. We would blaze

away with this with no feelings of guilt. Our targets were neighbouring cats and dogs and intruding hens. We rarely made a hit and

on the few occasions that we did we seemed to do no harm. In fact it was a very feeble weapon, and I proved it.

My sister Betty, with her back towards me, was bending over picking parsley in the vegetable bed. The target proved irresistible. I fired and hit her fair and square where her skirt was taut across a buttock. The pellet bounced off harmlessly. Its impact, however, must have stung her a trifle, for it brought her up with an angry jerk.

Now the effect of this incident on the females of our combined establishments, that is, Betty, Tetta, Rachel who was Tommy's sister, and our respective mothers, seemed to me at the time to be out of all proportion to the gravity of the deed. First Betty was severely injured, then she might have been killed, then again they were all in imminent danger of being blinded for life, as if I would have aimed at their faces, and so on and so forth. It took time to be forgiven and I was in bad odour for some days to come.

One summer holiday I returned to Wokingham from school to find the family installed in a new house. It was a hideous modern villa surrounded by a strip of waste land on the outskirts of the town. It had the even more hideous name of Milor. What a change from pretty Newton with its old walled garden.

The move may have been necessary for lack of space. My father had already left us for Haiphong, but my cousin Mary had returned to join us and the old house could no longer contain this horde of children in comfort. I suspect, however, that the reason for the move was partly due to the fact that my mother, like so many Far Easterners, was a restless woman. To move rather than improvise was, to her, the easiest solution. For me there was one point in favour of this new house. It was nearer to the Kimbers.

At this time I was learning to play the violin and for a short time at the beginning of the Great War I was taught by an elderly Belgian from the conservatoire at Liège whom my mother had befriended.

Betty and Tommy played the piano and the three of us would make music of a sort. Musical evenings were held at the Kimbers where we were often joined by a retired Anglican clergyman, a senile old gentleman who played the flute as badly as I played the fiddle and Betty and Tommy the piano.

The noise we made must have been excruciating, for we rarely finished on the same note. One or more of us were usually a bar or two behind. But I can still see Mr and Mrs Kimber sitting smiling in their armchairs beside the fire as if oblivious to our mistakes. Yet they must have suffered much.

Not long after we had established ourselves in Milor Betty was struck down by acute appendicitis. This was drama indeed. Tetta and myself were bundled off to stay with Grandmamma, while an eminent surgeon accompanied by a nurse came down from London. Betty, we learnt later, was operated on on the kitchen table and then spent some weeks in bed, a rapid recovery in those days. I can't

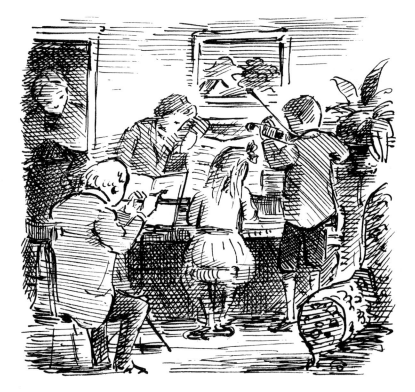

remember feeling much anxiety for her at this time, only, after all was well, feeling some resentment that she was now the heroine of the moment. I and Tetta's noses were put a little out of joint.

The advent of the Great War was the final drama. It ended our stay in Wokingham. All one hot August marching troops filled the streets. Column after column of infantry were followed by batteries of horse-drawn artillery and then by field kitchens with the chimneys of their mobile cookers smoking. Officers on horseback paced the ranks, while the occasional young aide-de-camp clattered by on his charger, his sword swinging by his side. For a boy it was all terribly exciting. I spent hours watching at the window, my eyes wet with tears as I felt that the war would be over too soon for me to take a part in it and fight for my King and country.

Not long after the outbreak of war my mother paid me a surprise visit at school. I was called out of class and directed to the headmaster's study where I found her waiting. Here she broke the news that she was about to brave the enemy submarines and raiders and return to Haiphong taking my two brothers with her, that this was goodbye.

The visit was a short one. I was soon back in class where I embarrassed both master and boys by sitting at my desk and bursting into tears. I was not to see mother again for four whole years.

On my next birthday I went to the school letter rack, but found no mail for me.

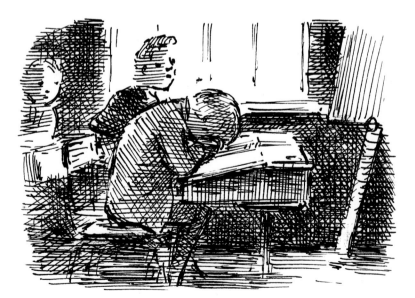

Clayesmore

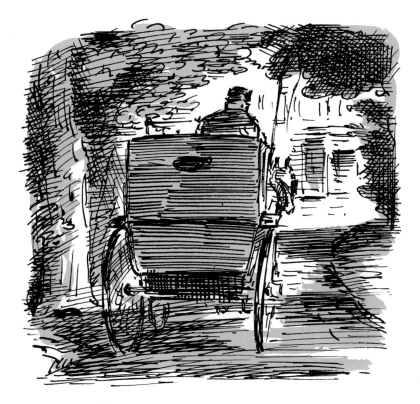

In September 1912 when I was eleven or, to put it more precisely, rising twelve, I left home for the first time for boarding school. My mother had already spent some days preparing my outfit and packing it into a tin trunk, ticking each item off against a printed list of requirements. This trunk was sent ahead by Carter Patterson, the carriers, while I set out wearing a school cap in black and purple, a stiff white Eton collar, a black Eton jacket, long trousers and black shoes. In my hand I carried what looked like a miniature Gladstone bag which contained my pyjamas, bedroom slippers, sponge bag, face flannel and toothbrush. A horse-drawn fly took me up the hill from the station to the school on the heights above the river Thames at Pangbourne.

The school was a large handsome Victorian building approached by a long drive through woods, and it was with some trepidation that I entered a rather grand front door to find myself in a milling crowd of boys.

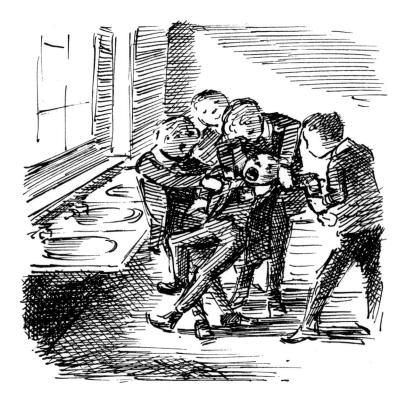

Thinking back, I find it strange that I was sent to Clayesmore. In the first place it was a non-denominational school whereas we were Catholics, at a time when much pressure was put on the faithful to send their sons to Catholic schools. Second, my father with his French upbringing had no knowledge or understanding of the English public school system. He would have preferred his children to have gone to a local day school. Clayesmore was in a way a compromise. Stonyhurst was too far away, Beaumont and Downside were too expensive and Clayesmore was cheap.

My first term had an inauspicious start. The junior boys had devised an initiation ceremony in which the head of any new boy was forced down into a washbasin and held under water until such time as the master of ceremonies felt the victim had had enough.

The idea of having my head held under water frightened the life out of me and I fought and resisted so violently that at least a dozen small boys failed to drag me to the basin and achieve their object. They had to give up.

I was, of course, not popular after this. In fact I was never a very happy, successful nor popular schoolboy. I always hated crowded playrooms and passages, the smell of hot water pipes, chilblains and the complete lack of privacy.

However this was for me a far, far better school than Ipswich. Though never very happy, I was rarely actively unhappy. There was much ragging but no real bullying. Clayesmore had about it an aura of gentlemanly, carefree eccentricity.

When I look back on the education we received I would describe it as more liberal than academic. Our standards all the way up the school were, from an academic point of view, pretty low. In my case little Latin and no Greek. Mathematics and chemistry were minimal and history patchy. We knew much of the French revolution and the Napoleonic wars, these being the headmaster's favourite subjects, but very little of anything else. French was good. All the same most of us managed before we left to scrape through the Oxford and Cambridge joint board examinations and a number achieved Little Go and the major universities.

Our headmaster, Alexander Devine, known by everyone as Lex, was an unusual man as headmasters go. He was short and stout and

of a dark complexion. When on his rounds he invariably smoked a large cigar and was preceded by his black cocker spaniel. The smell of cigar smoke and the advent of the dog would give us warning of his arrival and enough time to be on our best behaviour.

There was one occasion, however, when he dispensed with both and ran straight into a booby trap we had set for another boy. The suspense in the dormitory was awful when we saw the door opening and a number of our night bags come tumbling down, not on the head of our intended victim, but on Lex himself. However, he took it in good part and though he was usually free with the cane, none of us was punished.

One habit of his, and a nice one, was to read a bedtime story to a group of the youngest boys on Sunday evenings. We juniors, clad in pyjamas, dressing-gowns and bedroom slippers would squat on the floor of his study. In winter a large fire would be burning in the grate. The room would be dark, lit only by the glow of the fire and the confined light of a reading lamp at Lex's elbow. Lex was a good and fluent reader and obviously enjoyed the task. We in our turn loved to listen.

I remember one story in particular. It was by Annesley Vachel and was about a man who had the remarkable ability to project his voice.

To prove this ability to a friend he went to an open window and seeing a policeman on point duty far up the street whispered, 'Constable'. The policeman immediately spun round to see who was calling him. I was tremendously impressed by this and for weeks afterwards I would practise projecting my voice, saying, 'Cunsstible', in a sibilant whisper. Alas, I can still throw my voice unwittingly and so make an aside that can be heard by the wrong person, with the most awkward results.

How and why Lex started the school I do not know. I have an idea that Quaker money was forthcoming and that Lex's idea of the nobility of manual work may have helped to provide it. Certainly there was a period set aside each week for manual work, though I, during five and a half years at Clayesmore, have no memory of engaging in any.

The work consisted chiefly of road-making. Senior boys would parade in sweaters and shorts, carrying spades and rams and holding wheelbarrows in front of them before setting out to work. Sometimes the naughtier boys would pull down their sweaters over rolled up shorts, hiding the shorts completely, and caper about as if they had nothing on underneath, like girls in their mini skirts today. Presumably this was done to shock any of the female staff passing by.

It certainly shocked the juniors.

For some reason or another, Lex considered road-making the noblest form of manual labour. A romantic notion and he was, if anything, a romantic. I can hear him now on the grand sweep of history and the part played by roads in the dawn of civilization, on Roman roads which enabled Rome to govern an empire for 400 years, and on military roads echoing to the clink and clatter of cavalry or the drum beat of marching troops.

Our Junior Housemaster was a thin, elderly man with wispy brown hair brushed over the bald top of his head. His face looked sour and angry as if he suffered from chronic dyspepsia and hated boys. He disliked me on sight and I, him.

He was almost apoplectic with rage when, much to my surprise and everybody else's, I beat the favourite to win the Junior Cross Country race. My guess is that he had money on the result, more than he could afford to lose. He tried hard, by questioning me and others, to make out that I had cheated by cutting corners. Unfortunately for him I had had the favourite on my heels all the way, making cheating on my part impossible.

His end came when he was arrested by the police for being drunk and disorderly in the neighbouring large town of Reading. 'Poor chap,' said Lex, 'I can hardly blame him. Reading is such a ghastly town it would drive anybody to drink.' All the same he was not with us next term.

A hero to the Junior School was the maths master. He was a beefy young man who had some reputation as an amateur boxer. His methods of punishment in class were, like so much else at Clayesmore, eccentric. If you failed at your sums he would stand you beside his dais with a large bell jar over your head. If you were grossly stupid or inattentive he stood you on your desk, then knocked you off in order to give you a good shake up.

During my first year at school my favourite member of staff was Nurse Costello, the plump, middle-aged Irish matron. She was a motherly woman and popular with most of us, but her methods of dealing with our minor ailments could be Draconian and sound very old fashioned now. She treated styes and gumboils, for instance, by threading a needle and cotton through them. In the spring she would dose us with brimstone and treacle or, to be more precise, golden syrup and powdered sulphur, a gritty rather than nasty mixture.

At night I slept in a dormitory with seven other boys. One of them was a bedwetter and was known to all as the 'Haddock'. If you were awake at midnight you would see Nurse Costello glide into the darkened room. In her right hand she carried a long hat pin. Bending over the Haddock's bed she would push this pin through his bedclothes and prick him awake. A most efficient method of rousing a small boy heavy with sleep.

The school was later to move from Pangbourne to a village some

miles outside Winchester. This move was for me a major break in
my school career. It marked the transition from being a small boy
to more senior status.

However, before I leave the subject of Pangbourne there are
several memories, or rather, small pictures in the mind, which seem
to ask to be described. Memories such as filling tuck boxes with the
mushrooms that grew in profusion in the open parkland on one side
of the house. We would peel these mushrooms and with some careful
cajolery persuade the cook to prepare them for our supper. Then
there were the occasions when, with a little money in our pockets,
we would waylay the baker's van as it came up the wooded drive and
buy loaves of white bread, still warm from the oven, to eat on the
spot.

Once I found the newly killed body of a mole in a trap and skinned it with my penknife. I cured the skin in salt and pepper. The resulting pelt was hard as a board but made an excellent little mat for the doll's house at home. Then there was the attempt to make blackberry wine. A friend and I filled jam jars with juice from the fruit and buried them in a secret place in the woods. The resulting liquor, after a few weeks in the cool earth, was not actively unpleasant to drink, but it was certainly not wine and was so cloying on the palate that we were unable to finish it.

Another memory is of being near a senior boy when he fell down in an epileptic fit. He had the reputation of being immensely strong. I stood by helpless and bewildered, for I had never seen anybody in a fit before and didn't know what to do. There were others nearby who ran for help and in my mind's eye I still see Nurse Costello leading a slow procession of two men carrying a stretcher, followed by a gaggle of the curious, over the rolling parkland to bring aid to the stricken boy.

But the memory above all memories is of the great fight when I fought my best friend to a standstill behind the outdoor lavatories. Neither my friend nor I wanted to fight. We were having one of those absurd tiffs common to young boys, when one or the other of us had said, 'I'll fight you for that,' without really meaning it. Alas we were overheard and were immediately surrounded by boys shouting, 'A fight, a fight!' There was no backing out of it then.

We were hurried out, the centre of a mob of boys, to a small wood of thin scraggy oak trees, close to the main school. It was winter and the trees did not conceal the low building containing the lavatories. But a few yards behind this building, and thus partially concealed, was a concrete square which must have been the foundation for some future hut. This fifteen-foot square was our arena.

The only formalities insisted on were that we had to strip to the waist and fight bare-fisted like two small Tom Cribs. There were no seconds, no umpire and no rounds.

After a minute or two I became quite oblivious to pain and battered

away in a red daze until I was too tired to hold my hands up. My opponent was in the same shape and so the fight ended, stopped not by the spectators but because we were so exhausted we could not go on. It was a draw, there was no winner.

My face was little marked after the fight, but I gave my poor friend two of the juiciest black eyes I have ever seen. They lasted for half a term and the remains of the bruising was visible even when he returned after the Easter holidays.

It may be that he had particularly sensitive skin, but I do know that Nurse Costello was worried about the condition of his face. There were conferences among the staff and though I was not had up or punished in any way there was a certain coldness towards me, as if I had been some fearful bully. The coldness hurt most when it came from Nurse Costello who had been fond of me. It all seemed so unfair. Perhaps those boxing lessons I had had in Ipswich were in the end to prove a disadvantage.

However, at the end of it all, my opponent remained my best friend.

Clayesmore in war time

By the time the Great War had started Clayesmore had moved to the village of Sparshot.

The house was a large, rather undistinguished building and attached to it was a complex of stables and outhouses. It contained a large gymnasium next to an indoor swimming bath. The latter was a novelty for us, for at Pangbourne we had to trek down to the river to bathe in the pretty pool below the weir.

Around the houses were playing fields and beyond them many acres of woodland in which we could wander at will.

All together it was a delightful place, except that the lavatories were appalling — a row of holes in a wooden seat over a long shallow pan which was cleared I know not how often, but certainly not often enough. The result was that I was permanently constipated and would hold all until I could get to some pretty woodland dell and there relieve myself in comfort. I was therefore cured early in life of that strange notion that one cannot live well and do a day's work unless one has evacuated every day after breakfast. I soon lost the belief in *mens sana in corpore sano*; there seemed no truth in it.

To be honest, the lavatory accommodation was changed for the better within the year, but habits take longer than this to change.

Now Clayesmore may have been before the Great War a school of some eccentricity and Lex a great man though an eccentric as headmasters go, but our senior masters, both before and during the war

years, were able men. I did not like them and they did not like me, though for this I cannot blame them. I was not the sort of boy that masters like.

With junior masters it was another story. As soon as war had started we had one after another, some of them most curious specimens. They rarely lasted more than a term or two, but provided much fun for us while they were there.

Our first oddity was a dear and timid little Frenchman who had very little English and no knowledge of games. One day we, the boys of the junior cricket game, decided to teach him how to play, but being little devils, we invented for his benefit our own rules: rules in which the batsman had to face not one bowler, but four, all bowling at him simultaneously from various parts of the field. The poor little man retired both bruised and indignant.

Then to our immense delight we found he was afraid of horses and prepared a rag for him. One morning he was a little impressed

and touched to find us waiting outside the classroom and to be greeted with a polite, 'Good morning, Sir'. The door was ceremoniously opened and then, as he entered, quickly slammed and locked behind him. Poor man! He found himself shut in with the great white carthorse which pulled the roller.

Pandemonium followed. The Frenchman pounded on the door to be let out. The horse, which we had led with ease into the classroom, caught something of his panic and stampeded, knocking over several desks and urinating all over the floor.

The unexpected arrival of Lex put a timely end to the affair. I think he was secretly amused, but that did not mitigate the quality of the all-round beating that followed. There seemed to be an extra edge to it. It hurt considerably but we all, comparing afterwards the weals on our buttocks, decided it was worth it.

Four more oddities were to follow until the sixth arrived who proved to be a great man and was to become one of the most revered masters in the school.

These four consisted of a lugubrious Scotsman with a very red nose (I made a hideous caricature of him and was beaten for it), two sardonic young men who drank bottled beer in class and Daddy Holmes. Daddy Holmes was an enormously stout old gentleman with a walrus moustache who, like Mr Creakle, could only speak in a hoarse whisper, but who, unlike Mr Creakle, never attempted to keep order but let us do exactly what we liked.

The sixth oddity was our new French master, the Conte di Balme, known always simply as the Count. But what a name! It almost demanded a rag. Unfortunately I was not present when the Count

took his first class, being then in a more senior one, but the story of what took place, which probably improved in the telling, was soon known to all.

It seemed that a rag had been carefully planned. Its culminating point was when a small boy stepped out in front of his desk and asked the Count, 'Are you barmy Sir?' At this the Count descended from the dais and hit the boy a resounding blow which felled him, as if dead, to the ground. A ghastly silence followed.

The blow must have sounded worse than it was, as the boy, though suffering from a sort of shocked surprise, was totally uninjured. As

for the Count, at this moment he gained an ascendancy over and a respect from the boys which spread to the whole school. He became a loved and venerated master and a legendary figure in the annals of Clayesmore. Like all legendary figures the tales of him are legion.

The Count was an aristocrat, an ex-colonel of a crack Italian cavalry regiment and had been present at the fall of Adowa. He was a magnificent horseman, which particularly endeared him to us, and also very much a man of the world, a quality rarely found in schoolmasters but much admired by the boys. We always understood that he was a political exile, another point in his favour, and that Lex had met him in Paris living in rather poor circumstances and had brought him to England.

That he had little money beside his salary from the school I am quite sure since, when Lex died and the Count retired from teaching, it was only through the kindness of Miss Colson, who had been the school secretary, that he was able to live in reasonable comfort until his death some time in the 'thirties.

We, when at school, always thought that there was a romantic attachment between the Count and Miss Colson, and on looking back I rather hope there was. He was a fine man and she a charming middle-aged lady.

The Count was tall and very thin. He held himself as erect as a guardsman. He had thinning hair and a darkish complexion and a long, flattened retroussé nose under which he wore a pointed moustache which gave him a rather swashbuckling air. His English was good though he never lost his French accent and his phraseology was sometimes strange. 'I'll beat you to the blood,' was a favourite threat, though never carried out. In fact we all felt that he was really on our side.

As a French teacher he was absolutely first class. Under his teaching it became the best subject in the school and we all passed the Oxford and Cambridge Joint Board exam in this subject, some with honours.

In my day the outside examiner in French was an elderly Anglican clergyman. He would arrive at the school the evening before the exam. Rumour had it that the Count would give him a *recherché* little dinner in his room, fill him with Italian wines and liqueurs and then, when the dear old clergyman was a little tipsy, would obtain from him the details of the next day's papers.

I am sure this was untrue. But all the same it was rather surprising that, a short time before we sat for the exam, the Count would have us into his classroom and give us a talk on what to expect and the things we should remember, and, curiously, the Count was always right.

Compared to the boarding schools of today our régime in these war years was a spartan one. The dormitories were large and in the winter the water in the tin basins beside our beds was sometimes frozen. In the winter too we had, on getting up, to take a cold shower and in the summer bathe; a swarm of naked boys would hurl themselves downstairs and along the passages to the swimming bath, hurried on by prefects with knotted towels. Always before breakfast there was the morning run, a barbarous habit which I am glad has now been largely abandoned.

Like other schools at the time we had our own Officers Training Corps, barely Company strength, Clayesmore being a small school. An elderly retired major, who reminded me a little of Daddy Holmes, was in charge of it and he had an elderly sergeant to help him. Uniforms arrived. Dummy rifles were issued, plus a few real ones for us to handle, and an orderly room was set up in a small room beside the gym.

We dug shallow trenches in the hard, chalky ground, played at field days and went for route marches when we would sling our wooden rifles from our shoulders, wear our caps on the back of our heads, smoke cigarettes and sing the rudest marching songs, such

as, 'I've been out with the girls all night. Smell my fingers, smell my fingers', the significance of which many of us hardly understood. In fact we tried to be as much like the real thing as possible. Naturally, respectable villagers objected and complaints came in to Lex from the countryside around.

All this time news came at frequent intervals of old boys killed on the Western Front and the roll of honour grew.

As a senior boy my life at school was pleasanter than before, but all the same I was neither happy nor successful. I was large and clumsy and seemingly rather stupid in class though, before I left, I surprised everybody (and myself most of all) by passing the terminal examinations with credit.

I was hopeless at cricket but was good enough at soccer to play left-back for the school eleven; though I was probably the worst left-back the school had ever had and achieved what I would call reverse honours by kicking the ball into my own goal, thereby losing a needle match against another school. I boxed as a heavy-weight in the finals, but lost on points after a slogging match in which I caused more damage to my opponent than he to me. Running was

always my best sport and in my last year I won the cross country, mile, half-mile and quarter-mile, but was disappointed at the prize-giving to receive, due to war time economy, only purple rosettes instead of the expected silver plated cups.

Then came disaster. Lex appointed me as a prefect, a position which I soon found I could not hold down. I simply couldn't bring myself to exercise authority. I was ragged by the boys and hadn't quick wits enough to deal with the cheeky. Small boys had a horrid way of chanting behind my back, 'Ardizzone fat and bony!' When I had the unpleasant task of giving an official caning to a boy I could not, for some inexplicable reason, hurt him, though I tried hard to do so. My victim usually thought it something of a joke. Finally I went back to Lex and resigned my prefecture before the sacking I felt was inevitable. He accepted my resignation kindly, knowing, I suppose, how wretched I felt.

My non-success at school was not due to being a rebel. I wish it had been as it would have been a more respectable reason. I was a conformist. I tried hard to do the right thing but failed.

This unhappy situation drove me to take refuge in painting and drawing, a hobby already, but even more so now. I lost myself in hours of doodling, making up odd monsters, caricaturing boys and masters and inventing strange landscapes. During free time in fine

weather I would be out and about attempting to draw the local landscape, in particular its trees. I was, of course, an active member of the art class run by Miss Annie Hazledene. And, on looking back, I realise I owe much to her.

Annie Hazledene was a parson's daughter. She was neither very young nor very beautiful. She wore pince-nez and had a nose like a little boot. Yet she had a kindly enthusiasm to which I responded and which helped to keep my own enthusiasm alive.

In class we would draw pots and pans, vases of flowers and the few plaster casts the school possessed. Occasionally a boy would be made to pose for us and it was my drawing of one of these boys which gained for me a bronze medal from the Royal Drawing Society. Sometimes, under Miss Hazledene's tutelage, I would paint small watercolours of the school garden.

All this today sounds dreadfully academic and more suited to a genteel girls' boarding school. All the same it gave me an increased dexterity in hand and eye and in the use of my materials which helped me greatly when I came to depict that make-up world I was to pursue on my own.

Unfortunately Captain Coke, my housemaster, disapproved. Yet he was the one man whose commendation I badly wanted.

Desmond Coke was a novelist and author of that well-known book *The Bending of a Twig*. He was a scholar, a man of means and a man of taste. He collected pictures and *objets d'art*. His collection of miniatures is now in the Victoria and Albert Museum. It was natural that I should turn to him as an arbiter in the arts. But I fear he looked on the products of Miss Hazledene's class, mine included, with distaste, thinking them both vulgar and banal, which of course they probably were. One particular drawing by another boy who was not a member of our class and of whom I was a little jealous, he praised highly. It was the kind of drawing I was many years later to call the sensitive mess.

My last term at school passed pleasantly enough. I was made a prefect again, but took my duties lightly. The weather was fine; I was excused cricket so spent many happy hours idling or doodling in my sketch books.

At the end I left with no regrets and with a great sense of relief that my school days were over.

War-time holidays with Grandmamma

My parents being abroad, I and my two sisters spent most of the holidays with my grandmother.

She had by then moved from the large house with its tennis court at Shiplake to a smaller one in the same village. This house, a white, mid-Victorian building, was hidden from the road by a thick shrubbery. At the back french windows opened from the drawing room on to a lawn which sloped gently down to a backwater of the Thames. At the water's edge was a small wooden landing stage, with, in the summer months, a punt moored alongside. On warm days and when the sun shone one could, if one approached the stage with caution, see a large pike sunning itself in the shallows almost at one's feet.

During winter and early spring when the Thames was, at times, in flood, we were able to see, through the bare thickets of the island opposite, a great expanse of hurrying water. In the worst floods the island and half our lawn would be submerged.

Shiplake, like many Thames-side villages, had a prosperous air. The houses were well kept and, in their new paint, smart to look at. They were set in neat and well kept gardens. Many of the people who lived in these houses were smart too. There was about the whole village and its inhabitants a faint yet quite definite air of raffishness. A number of divorced wives, and husbands for that matter, lived among us. There was even a middle-aged couple who lived happily together as man and wife but had not been married.

My grandmother, of course, knew everybody who was anybody in the village. I remember some of their names still. There was Sir Frederick Gorel-Barnes and with him his children. They had a large living room built over a boat house. The floor of this room was of polished wood. So too were the walls which gave it a sort of holiday aquatic look which intrigued us. His son was, I think, older than I. In any case he was far more sophisticated and in consequence I was in awe of him and hardly knew him.

Next to our house lived Lady Weldon, another stout buddy of my grandmother's. Lady Weldon's husband was in the College of Heralds. He, as a hobby, painted large pictures in pastel of various heralds in their gorgeous costumes. I thought they were splendid. A little farther away lived the Buddicombes and farther still, Lady Warren.

With Lady Warren my grandmother had a great row from which she retired the loser. For a week or two she was a chastened woman.

Grandmamma had a habit of speaking her mind in public, worse still, in a penetrating voice. Many a time I and my sisters would shrink away red-faced with embarrassment while she stood at the

garden gate of some villa, swaying a little from side to side, and with a pointing finger discuss in tones which could be heard a quarter of a mile off the demerits of the occupants, the hideousness of their curtains and the stupidity of their children. In the case of Lady Warren it was my guess and my sisters' too that our grandmother had gone too far and was threatened either with a court case for slander or at least the task of making a formal apology.

For the young people there were parties in the neighbouring houses. But these often led to trouble for us. My grandmother would insist on my sisters wearing frocks which they hated. We got round this in the following manner. The girls would make up a brown paper parcel of the frocks they wanted to wear and I would sneak out of the house some time during the day and plant this parcel behind a convenient hedge which was on our route. Then on the way to the dance the girls would nip behind the hedge and change into their chosen garments.

On the way back the plan was put into reverse. Behind the hedge again they changed back into the frocks my grandmother had chosen. Those worn at the party were parcelled up and hidden in the shrubbery by the gate until they could be retrieved by one of us the next day.

Unfortunately this ruse often failed: some well-meaning neighbour would tell my grandmother how nice Betty looked in blue or Tetta in red, when they had been sent out dressed severely in

brown. Then there would be wigs on the green and Betty and Tetta would be in disgrace for an hour or two.

On one alarming occasion my grandmother was out walking with my sisters, in one of her moods of black rage; it reached a crisis and she had some kind of a fit, falling unconscious into the hedge. The poor girls were uncertain what to do, but having read that it was important to loosen the patient's stays as a preliminary to getting help, they made desperate efforts to get at the laces of that formidable garment. However, perhaps due to their amateurish fumblings or to the touch of their cold hands on her skin, the old lady came to, got up and stumped angrily home and then to bed.

Tommy Kimber from Wokingham was an occasional visitor and would stay with us for a week or two in holiday time. One fine Easter he and I spent much time among the thickets on the island, which we explored from end to end. It was the close season for fishing but the desire to angle for the fat perch which swam lazily in the deeper water by the banks proved irresistible.

Armed with lines and hooks and bread for bait we would slip across the wooden bridge which connected the island with Lady Weldon's garden and find some hiding place in the undergrowth by the water's edge. Here, lying face down, we would peer into the water. The fish were so idle and so somnolent that they almost seemed to wait for our baited hooks to be lowered into their open mouths. Once caught we would let them run out with the line in the hope that the big pike would gobble them whole and thus become our victim too. In this we failed.

Another visitor, but always in the summer, was Mrs Chapman. She would arrive in her big chauffeur-driven car and great was the rejoicing when she and my grandmother met.

My first duty on these occasions was to clean out the punt and furnish it with the necessary cushions. Then, when all was ship-shape, help them on board and see that they were comfortably seated, one facing the other, and paddle them slowly out of the backwater and into the main stream.

While I paddled they talked, and how they talked, an unceasing flow of conversation. I think they even forgot in the excitement of all this talk that I was there, because they interlarded it with decidedly *risqué* stories. At each story they would laugh till the tears ran down their cheeks and the whole boat shook with their laughter.

Of course they may have thought that I was too young to understand. I knew that I was not expected to join in the merriment and did not do so.

During the holidays I did not indulge in my hobby of drawing and painting. This was reserved for unhappy days at school. But in cold, wet weather when we were confined to the house I would pore over Doré's illustrations for the works of Dante. These we had in a stack of paper-covered parts, each part being of a large quarto size and containing one or more splendid engravings. The engravings for *Inferno* were my favourites. I was fascinated by the bulging muscles

of the naked male sinners and wondered at times if all the muscles worked. I was also fascinated by the flowing curves of the women. I would copy both.

One of the many activities of the village was to produce concerts for the soldiers. It was considered valuable war work to raise the spirits and lighten the tedium of the poor boys in camp. Our local ladies took to the task with enthusiasm and we were all, even my sisters and myself, roped in to take part.

How we young Ardizzones hated it and how, I am sure, the poor boys hated it too. But they, since their officers and senior N.C.O.s were present to see that there was no ribaldry, were a captive audience. From the shuffling of feet and the occasional muffled groan one could guess at their boredom.

The *pièce de résistance* of the concert was usually a one-act farce in which Betty or Tetta would have a part. Then there would be interminable songs, piano pieces and recitations. My part in all this was to play the fiddle. I remember only too well my misery as, standing behind a curtain (I was much too shy to stand in the open), I fumbled at the opening bars of Handel's *Largo*.

In 1915 my grandmother rented a house for the summer holidays in the little seaside village of Trevone on the Cornish coast. Here Uncle Laurie and Aunt Alice came to stay with us, and also Tommy Kimber for a week or two.

My chief memory of this holiday is laughter. I and my sisters were at the age when most children are prone to the giggles. But we not only giggled unceasingly, we were inflicted from time to time with hysterical laughter. We laughed till tears ran down our cheeks and our sides ached so much that we almost prayed to be able to stop.

It all began when my grandmother, being in one of her great rages, called poor Aunt Alice a snake in the grass. But Aunt Alice, like grandmamma, was very stout, and the vision of her edging her way on her belly through the grass, her white face, crowned with its mop of black hair tied in a bun, thrust ahead and her large backside undulating behind, was too much for us. We collapsed into helpless mirth and continued to do so every time we remembered it. I think we must have been impossible children.

Aunt Alice was to be the cause of yet another mirth-provoking incident. It was the seventh wave that did it. Surprised by this monster she was buried in its depth and momentarily lost to sight. Floating in front of her a mop of black hair, either her wig or her toupé, beat her to the shore.

Yet again, at a concert in Padstow we found the actions of the cellist irresistibly funny. He was a long-haired young man who wagged his head in slow motion as he played. We, with heads bowed, shook with suppressed laughter, to the annoyance of the audience near by. To repeat, we must have been impossible.

At this time the spy scare was at its height. A harmless middle-aged couple lived in a bungalow on the hillside behind our house. They were a little careless with the blackout and on occasions a gleam of light could be seen from one of their windows. Tommy Kimber and I decided that they were enemy agents, so for a few nights in succession we lay out under a clump of bushes and watched. We hoped to see an answering light from some low craft far out at sea, or hear the scrape of a boat against the rocks below and the sound of gutteral voices. But we were always disappointed and soon tired of this sport.

Tommy's last week with us was marred by sickness. The weather being set fair he and I set out on our bicycles for a few days' tour of the countryside. We proposed to sleep out. My grandmother, the eternal optimist, had seconded our proposal with enthusiasm. 'No need,' she cried, 'no need for sleeping bags and tents and all that stuff. You're strong boys. A blanket each and a hedge to sleep under is all you need.'

That night was a disaster. We made our primitive encampment at dusk. I went off to a distant farmhouse to buy milk. The journey was long and difficult as it entailed crossing a stream and climbing over a barbed-wire fence. I arrived at the farmhouse to find I had

lost on the way my one and only coin, a half-crown, and so had to return empty-handed. Tommy in the meantime had failed to make a fire. We then tried to boil some eggs in a tin can over a bicycle lamp. This was a failure too. In the end we wrapped ourselves in our blankets and prepared for sleep.

I woke up cold and stiff with the impression that I had been asleep for hours. Noticing a glow in the sky I shook Tommy awake and suggested a dawn start. He agreed as, like me, he too was cold and stiff and only too happy to get on the move again. Hastily we packed up and rode away.

Alas as we went on, the sky, instead of getting lighter, grew darker. I realized that what I had taken for the dawn was only the last light of day. However we went on for an hour or so until exhausted, when we flung ourselves down behind another hedge and slept till the true dawn appeared.

If we had been cold and stiff the night before it was nothing to what we were that early morning. We had no means of making a hot drink to warm ourselves. We were miserable.

Then it was as if the fates had relented a little. We smelt on the morning breeze that most wonderful of all smells, the smell of baking bread. A few yards down the road we found a country bakery.

Tommy bought white loaves, one for each of us. They came piping hot from the oven. These we spread with potted meat and devoured while we stood in the doorway of the bakehouse, enjoying the warm air from within.

But by now Tommy was not feeling very well, so we turned for home which we reached by lunchtime.

My grandmother was greatly annoyed at our arrival. She had expected to be rid of us for at least three days. However, seeing that Tommy looked a really sick boy, she controlled her temper, dosed him with Epsom salts dissolved in hot water and put him to bed, where he remained for the best part of a week suffering from a chill on the liver.

One summer holiday I and the girls were boarded with an elderly clergyman and his grown-up daughter. They lived in the village of Babbacombe near Torquay.

The clergyman was a grumpy old man and the daughter a sad, plump but faded woman in her thirties. One evening when her father was in bed she told us, with tears in her eyes, how he had prevented her marriage with the man she loved by the cruel device of intercepting their letters. Now the lover had gone for good and she

was left an ageing spinster and slave to her father.

I was filled with a tender emotion and longed to hold her in my arms and comfort her. But being only fifteen I neither had the nerve nor the necessary words to do so. My sisters may have felt the same, though I doubt it. Girls, when it comes to others of the female sex, are in the nature of things less sentimental than boys.

The clergyman was in truth something of an old brute. We had bicycled to Teignmouth to spend the day with some friends of my grandmother and the ride back in the dark had taken longer than we had expected. We arrived shortly after the allotted time for our return, to find the door locked and the windows fastened. The night was fine and, as we were afraid to rouse the house, we prepared to sleep on the lawn. The old man, of course, heard us and came down in his dressing-gown to open the door. In grim silence he let us file sheepishly in without so much as a word in answer to our apologies, then barred and bolted the door behind us.

It transpired that he had forbidden his poor daughter to sit up for us, but had reserved for himself the task of letting us in in order to make our return as unpleasant as possible. He hardly spoke to us again for the rest of our stay.

We had no other children of our own age for companions, but the

weather being fine we enjoyed ourselves well enough. On several occasions we visited the Teignmouth friends. They had a delightful garden. In it was a spring of cold water which gushed out from under a rock. They would place bottles of milk or lemonade to cool in its icy water. At tea, which was served in the garden, they would give us delicious split buns filled with Devonshire cream and raspberry jam.

On other days we would bathe, idle on the beach, visit Torquay or roam the countryside. One afternoon Betty and I hired a rowing boat and went fishing for mackerel. While one of us rowed the other trailed a line with baited hook over the stern. Betty was the lucky one. Three times she prayed to St Anthony and three times she caught a fish; I caught none. I felt a bit sore about this. It was most unfair and anyhow she was praying to the wrong saint.

Bath

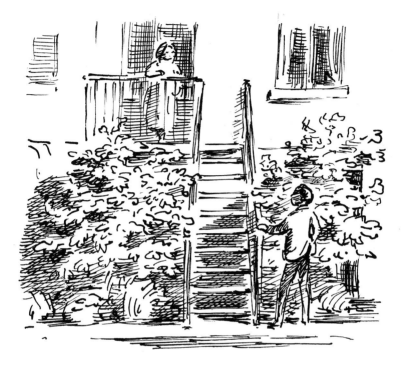

Early in 1918 my mother, having braved the submarines, returned to England with my two brothers. She rented a house in the city of Bath and there made a home for us.

The house was situated near the top of Lansdowne Hill and was one of a row of basement and two storey white houses built in the 1820s and separated from the road by a railing and a few flower beds. Behind the house and of the same width was a long, narrow, walled garden. If one looked over the end wall one could see the city spread out below. It seemed to us as a mountain garden. Besides the view another special feature of the garden was the two fine fig trees, one bearing white and the other red figs, which grew against the back wall of the house.

The basement which contained the kitchen, pantry and maid's room was below ground in front, but at the back at garden level. The floor above contained the drawing room and dining room. French windows in the latter gave access to a small iron balcony from which steps led down between the fig trees to the path below. All in all it was a pretty place.

As soon as mother was installed she took my sisters away from

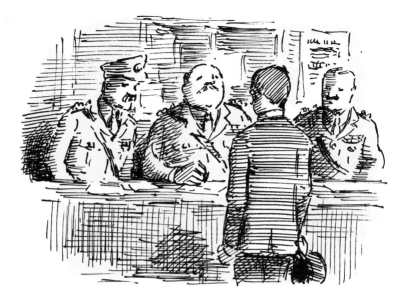

their convent school and sent them as day girls to Bath High School. My brother David she packed off to Clayesmore. I was still there then but left for good at the end of the following term.

Like most boys at that time my one desire was to join the Army as soon as possible and fight for King and Country. With this in view and on the advice of my Uncle Alec I took a train to London to go before the selection board of the Artists' Rifles.

I set out dressed with particular care for the occasion, my shirt

and collar spotless, my suit a new one. I wore spats and my shoes were polished till I could almost see my face in them. I carried brown leather gloves and a malacca cane. On my head I wore a bowler. I felt very grown up and something of a blood.

Unfortunately I made a boob of the interview. The row of middle-aged officers seated at the long table before which I had to stand, their clipped moustaches, their Sam Browne belts and many medal ribbons, the staccato way in which they put their questions all made me nervous. I obviously gave very foolish answers as my application was turned down unhesitatingly and on the spot. So, crestfallen, I returned to Bath.

In Bath a few days later I had another extremely unpleasant and humiliating experience. I was walking down Milsom Street when a girl, a horrid stout girl dressed in white, wearing a large white hat and with a silly smile on her round moon face, handed me a white feather from a tray she carried in front of her. I did not take it but brushed past her feeling deeply hurt and upset.

On October 16th, my eighteenth birthday, I went to Bristol to enlist. To my intense surprise I was turned down again, this time on health grounds. They said I had an aortic murmur.

The process of trying to enlist was not a pleasant one. I had to wait for hours in a dimly lit hall among a great crowd of rough look-ing conscripts. Some were drunk and many much older than I. Then I had to stand stark naked for what seemed more hours among another crowd, all as naked as myself, waiting for the brief medical examination.

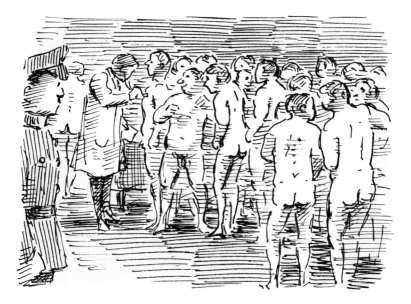

When I arrived home very late that night, having climbed on foot the long hill from the station to our house with no ill effects other than depression and tiredness, mother was at first surprised to see me back, she had thought her next sight of me would be in uniform months ahead, and then alarmed when she heard my news. A doctor was summoned the next morning. He could find nothing wrong with my heart. Fate or chance had decided I was not to be a soldier, at least not in that war.

I was now at a loose end. The idea that I should study art seriously or the possibility that I might become a professional artist never occurred to me. I had even lost interest in the subject which I had thought of only as a hobby. I did not know what to do.

At my mother's suggestion I enrolled in a six-month course at Canning's College, our local school of commerce. Here, for the first time in my life, I was considered brilliant. To be truthful, the competition was slight. My fellow pupils, boys and girls from nearby board schools, seemed to be almost illiterate. My essay on the filing system was considered a classic and remained for all to read on the notice board for weeks.

Mr Canning, the principal, was a somewhat pompous man who

not only taught the senior pupils but looked to their morals as well. I had taken to lunching at a tea shop on coffee and doughnuts with another pupil, a rather forward little hussy. Mr Canning did not approve. I was summoned to his study and duly warned against her.

By the end of the course I could write a respectable 120 words a minute shorthand, which I could read back. I could also type at a fair speed without many mistakes. On leaving I was offered the post of teacher in the college. When I refused, I could not stomach the idea of the job, Mr Canning solemnly prophesied a brilliant commercial career for me. Little did he know.

During the last months of the war and for some time after the armistice, shortages of food and consumer goods rather curtailed our social activities. On armistice day it poured with rain. We stayed at home and took no part in the communal rejoicings. But later there were dances at the Spa Hotel. Betty and I went to one. She in her party frock with her hair up and I in my first dinner jacket, high-winged collar and stiff boiled shirt.

We knew no one at the dance and were too shy to introduce ourselves. However we happily danced every dance together, tried prawns in aspic which we voted disgusting, enthused over the cucumber sandwiches and iced lemonade. We even religiously filled

in our dance programmes. In my case it was Betty, Betty, Betty all the way down and in hers Ted, Ted, Ted. Once home we declared that we had had a wonderful time.

We did in time, through being members of the tennis club, get to know a number of boys and girls of about our own ages. Chief among these were the three youngest members of the Walker family, Mary, Ann and Gregor. Their father, Captain Walker R.N., was dead. Their two elder brothers were away at sea serving in the Navy and their elder sisters grown up and away too. What attracted us to them was first their Naval background, then their mother, whom we liked enormously and who was surprisingly tolerant about the goings on of the young, and finally their gaiety and sophistication. We were to meet them again in London and become life-long friends.

Jobs

My first job was in the office of the Warminster Motor Co. in the small town of Warminster. The town in those days was not much bigger than a large village. It did boast, however, a red brick town hall, a large inn called The Bath Arms, two banks and numerous pubs. Near by was a camp of Australian soldiers waiting to be repatriated and the great house at Longleat belonging to the Marquis of Bath. It was also far enough from Bath to make it necessary for me to board with an elderly lady during the week, but near enough to go home at weekends.

I am afraid I did not live up to Mr Canning's solemn prophecy. I was not an efficient secretary. My shorthand soon became debased into a kind of quick longhand, my typing was slovenly and inaccurate. I filed papers in the wrong folders and probably spent more time than I should idling or talking to the girls in the office. However I was not bad enough to get the sack. I enjoyed it.

I enjoyed the freedom of being on my own and away from the family, also the feel of my own money in my pocket. Money which I had earned myself. I enjoyed too evenings in the bar of the Bath Arms drinking beer with the bank clerks or whisky with the Australian officers from the camp. The landlady, a stout old party, would sit with us until towards closing time by which time she would

be so drunk that she had to be led off to bed by her maids.

Warminster also had its excitements. There were girls, the unsuspected strength of parsnip wine, the fancy dress dance at the town hall, and, above all, the riotous behaviour of the Australian soldiers. These men were bored with waiting to go home and ill-disciplined to the point of mutiny. They wrecked the pubs and fought with broken bottles and glasses. They coshed unwary pedestrians after dark and stole their money. The local police were afraid of them and hardly dared to show themselves on the streets when they were about. One afternoon two gangs fought a revolver battle in the road below the office windows.

The fancy dress dance, or rather ball, was a great affair. It was

attended by all the town notables and their wives, members of the borough council, tradesmen, the clerks from the two banks and many young people who had been able to find the money for the ticket and make or acquire a fancy dress.

One of the bank clerks, a thin, delicate looking young man with pale hair, pale eyes and a long, lugubrious pale face, a drinking friend of mine at The Bath Arms, had decided in secret to go a bust and hire his costume from Clarksons in London. To my delighted surprise and suppressed mirth he clanked on to the ballroom floor dressed as a Roman soldier in full military rig, helmet, breast plate, spear, shield and all. We danced on that festive evening waltzes, foxtrots, one steps, the Boston two step, Maxinas, Valetas and

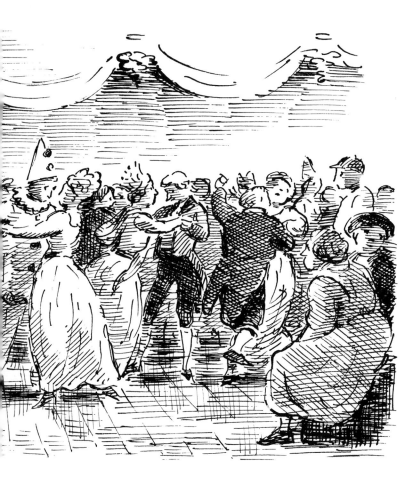

the Paul Jones and finished up with a reel.

For one week we were visited by a fifth-rate theatrical touring company who acted *Roses of Picardy*, a sentimental war play, at the local cinema. I was, one day on my way to Bath, to meet the cast by chance at the railway station and to travel in the same carriage with them.

My first sight of them was on the platform. They were standing or walking about near the big wicker baskets that contained their props. Theatrical folk were new to me and I looked at them and listened to their talk with interest. They seemed so different from the ordinary run of fellow travellers. The leading man wore a long black overcoat with a moth-eaten fur collar and a wide-brimmed black hat. He had, as he paced the platform with the leading lady, a sort of theatrical swagger. He did not converse, he proclaimed as if on the stage.

The leading lady, too, had made some attempt, though not very successfully, to look smart. The rest of the cast were woefully shabby. I noticed while sitting in the carriage that their shoes were in a wretched state. Many had split seams and all were so down at the heel that they would have shamed a tramp. They must have been very poor. Indeed they looked dispirited and I wondered whether

the box office takings had been insufficient or the manager had absconded with the cash.

After six months at Warminster I was asked to apply for the post of shipping clerk to the China and Japan Trading Company. Who arranged this I have now forgotten. It did, however, entail a three-day visit to London. It was during these three days that I, for the first time, had the experience of being really drunk.

My gay Uncle Alan took me out to dinner. After numerous cocktails we dined at his club. Oysters were the first item on the menu. I accepted, thinking it the right thing to do, but never shall I forget my horror and revulsion at the first taste. I grew to love them dearly in later years. Then, with the help of much cayenne pepper and lemon juice, I managed to gag down the dozen on my plate. We had wine through the meal and port and brandy after. When he took me to see one, two or three lady friends, I was beyond counting at this stage, I was speechless. For me the evening ended when he shoved me through the door of my lodgings and I was sick all the way up the stairs, much to the wrath of my landlady the next morning.

Never have I felt so ill. But I did get the job.

My grandmother, being the great mover that she was, had now installed herself in a flat in Cornwall Gardens in London and I

came to live with her and travelled each day by bus to work.

The offices of the China and Japan Trading Company occupied one floor of a house in East India Court, a small cul-de-sac or rather long, paved yard leading off Leadenhall Street. Eighteenth-century houses lined each side of this narrow yard and it was quiet as no traffic could enter in. The yard has gone and new buildings have taken the place of the old, which is sad as they once contained the offices of the great East India Company in which Charles Lamb used to work.

The curious thing about the China and Japan Trading Company was that it did no trade with China or Japan. Instead we sent whisky to Callao, straw hats and holy pictures to Baranquilla, needles, a most costly merchandise when in bulk, to Caracas, and cases of assorted merchandise, such as tinned meat and fish, to places like Tegucigalpa and Bluefields in central America.

Our offices consisted of three rooms. I worked with two other clerks and a typist in the largest one. Next door was a small room for the manager and beyond that a slightly larger room in which sat the two partners. It seemed very dark and dusty with little light coming through the grimy windows; but it was cosy in winter when coal fires burned brightly in every room, casting reflections on the brass knobs of the safe, the copying press and the pieces of polished furniture.

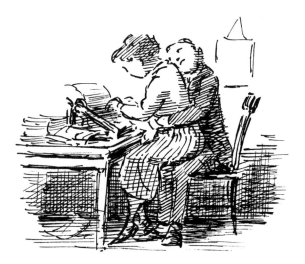

I and my fellow clerks worked at a long, high desk which ran the length of the room. We would either stand or sit on high stools while we entered figures into ledgers or wrote out ships' manifests. Occasionally one or other of us would have to dictate a letter to the Liverpool agents. Then the procedure was both simple and pleasurable. The lucky one would seat himself in the typist's chair, sit the girl on his lap, hold her firmly round the waist and dictate slowly while she rattled away on the keys.

Being the Junior I was sent out on all the errands. The office of Haig the whisky distillers was a favourite port of call because in the waiting room, standing in the centre of a large table, was a decanter of their best whisky with a jug of water and glasses for the visitor to help himself.

Occasionally I would have to spend the best part of a day in dockland, wandering through the West India and East India docks, the Royal Albert or over the river to the Surrey Commercial, looking for lost cargo. These were red letter days for me.

Within the year the China and Japan Trading Company came to an end. I will never forget the face of poor little Mr Diplock, our manager, when this happened. It was grey with worry and his look of despair haunts me now. Jobs were difficult to get in those days and particularly so in his case as he was already middle-aged.

I soon obtained a temporary post with the Liverpool Marine and General Insurance Co. and spent the next six months as a Bordereau clerk, twizzling the handle of a calculating machine, before I got my final job in the statistical department of the Eastern Telegraph Company, which I was to endure for the next six years.

In 1920 my father, on leave in England, bought the long lease of a house at 130 Elgin Avenue, Paddington, and installed his family in it before leaving once more for the Philippines. It was from this house that I went every week-day, including Saturdays, to the Telegraph Company, and it is in this house that I have lived ever since.

The office in which I worked was at basement level. It was a large, vaulted room. There were no windows, but the inner half of the room was lit by a glass roof. What daylight reached us had to filter down a deep well or shaft in the centre of the main building and then penetrate the protective chicken wire and dirt of the glass. It was, therefore, not strong. In consequence much of the room, even with artificial light, no strip lighting then, was shadowy.

In a dark corner by the stairs stood the copying press. When letters were typed, and before they were sent out, they were put between the leaves of a leather-bound book, the leaves being previously damped. The book was then put in the press and pressed. When the letter was taken out it had a smudgy and purple look. The copy in the book was smudgier still. It was our filing system.

Sometimes of an evening when lights were being put out and we were preparing to leave, the ratcatcher would arrive to begin his nightly task. He was a strange-looking little man with rather protruding eyes, a sharply pointed nose and a little fair moustache, which made him look rather like a rat himself. He carried no traps or other paraphernalia, but only a small sack.

My immediate boss was a kindly man. He was small in stature, wore an immense black moustache and impressed me much by telling me that he always carried £20 on his person in case of an emergency. This sum seemed enormous to me, whose salary was only £10 a month. I got on well with him and well too with the four senior clerks, the three juniors like myself and the three women, not girls, who comprised the staff.

Next to me worked a cheerful yet earnest young man. He was a Christadelphian. He neither smoked nor drank fermented liquor nor went to theatres and cinemas, nor used bad language, nor indulged in any of the normal peccadilloes of the young. He was extremely conscientious and an admirable employee. Unfortunately he would tell me little of the strange sect to which he belonged. All I could learn from him was that they believed in the prophecy of the pyramids and that the English were one of the lost tribes of Israel. I was dying to know more.

For the next six years my work consisted chiefly of writing columns of figures on large sheets of ruled paper, then adding up the figures, first crossways making a series of totals down the right-hand side of the paper, then from top to bottom making another series of totals along the bottom edge. Both sets of totals had to balance. We had adding machines to help us, but as there were not enough to go round much had to be done in our heads. As a job it was incredibly dull.

It was not long before I had become very quick at adding up, which left me with much free time. Unlike my conscientious Christadelphian neighbour, I did not ask for more work to fill it. The task was too wearisome. Instead I returned to my old love of drawing with added zest. I doodled, I drew and caricatured my office companions, invented strange landscapes and, having looked at a book of anatomy, produced imaginary anatomical drawings of flayed monsters.

I would sit or stand at my desk with a large statistical sheet in front of me, flanked by ledgers and seemingly hard at work. In truth I was drawing on little bits of paper. I was proud of these little drawings and when at home would paste them into exercise books.

At home I also continued my practice of drawing, extending the scope of my knowledge and drawing more from life. Then I joined Bernard Meninsky's life drawing evening classes at the old Westminster School of Art. This was a turning point in my career. The classes took place three evenings a week and I attended them regularly for the six years I was at the Telegraph Company.

It was at these classes that I was to meet Gabriel White, who was later to become my brother-in-law, and Augustine Booth. We three were Meninsky's pet pupils. Meninsky rarely criticized our drawings and then only to praise something good about them. Occasionally he would make a small drawing on the edge of one's paper to explain a point of draughtsmanship.

The real teaching came after class when we would retire to the local pub. Over a half pint of beer Meninsky would talk. He talked of the Renaissance draughtsmen and of Signorelli in particular. He made us aware of the beauties of Poussin and led us up to Cézanne who was to become our God.

I had had a short spell of another kind of tuition that did not suit me. In my early days in the Company I scraped together enough money to be the paying guest for one week of an elderly Royal Academician who lived in Dedham. Apart from introducing me to Munnings, whom I did not like, he taught me nothing. My painting was deplorable. He once told me that he could recognize thirty-seven different kinds of green, as if it was a virtue. I wondered at the necessity or validity of such a skill. When I came to leave I asked his advice about becoming a professional painter. He dissuaded me. I had not, he said, the talent.

The Telegraph Company, like many large firms, was highly patriotic. It extended the fortnight's paid holiday given to its employees by one week if they in their turn joined the Territorial Army and spent a fortnight in camp and attended a certain number of drills during the year.

Some of my fellow clerks belonged to an anti-aircraft battery and I enlisted in it too. Our drill hall was at Putney and our summer camp at Watchet in Somerset.

I quite enjoyed my brief acquaintance with military life. Gunnery has its interests and much beer was drunk in the gunners' mess when drill was over. I doubt if the people of Watchet liked us much. Our three-inch 20 cwt. guns were noisy and the sound of them firing all day in fine weather must have disturbed the holidaymakers. In the evenings we would don our bandoliers and spurs and swagger into the town and fill the pubs to bursting point.

I also joined the Exiles, the company's sporting club, and on Saturday afternoons in winter played rugby. At last I found a game I was good at. At least I was good enough to play on occasions for the first fifteen against such formidable opponents as the London Welsh and the 'A' teams of the Harlequins and Rosslyn Park. Here again much beer was drunk in the club house after games and a certain amount of horse-play indulged in.

Dancing days

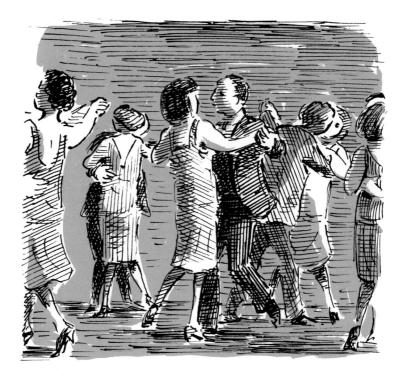

We were now entering the dancing age, and how we danced! The young men of the period sported pork pie hats and Oxford bags. My sisters' skirts grew shorter and their waist lines fell to just above their buttocks. My youngest sister Tetta, the dark one of the family, was a beauty. Her black hair was bobbed and combed down into a bang in front, from under which she peered with liquid brown eyes at her boy friends. When my sisters went out they both had their cloche hats pulled well down over their heads and were so heavily powdered that my mother complained that they looked as if they had put their faces in a flour bag.

Anytime, lunch time, tea time, dinner time, was dancing time. We foxtrotted, onestepped, twinkled, Charlestoned, tangoed and blackbottomed. Should any visitors call, if only for a few minutes, back would go the carpet and we would dance to the gramophone. None of us played instruments but friends did and so we had a Jazz band. We even ran a dance club in a large room above a billiard hall in Westbourne Grove. Our favourite tune was *Limehouse Blues*.

The Walkers came to town and added to our gaiety. They had established themselves in a flat overlooking the canal nearby and there was much traffic between the two families.

Big parties and dances took place in the large first-floor room at home. Often they lasted all night. At dawn in summer time we would sit out on our balcony and watch the early sun casting brilliant shafts of light across the avenue where the side roads joined it. The Walkers, their rooms being smaller, gave more intimate parties at which we played sardines or, towards morning, strip poker.

The girls always cheated at this, as they insisted on regarding some pretty trinket like an earring as an article of clothing, and I do not remember them ever being reduced to nakedness. The boys on the other hand often lost all. Poor Henry, Mary Walker's fiancé, having gambled away all his clothes, wagered half his moustache. He lost and shaved it off, much to Mary's anger.

As we were all impecunious we rarely drank wine or spirits. Instead we bought quantities of beer, which we would fetch from the Off Licence, or 'Jug and Bottle' in bedroom jugs.

On looking back to the early twenties I still wonder at the permissiveness of Mrs Walker and of my mother too. We must have been very wild and very noisy, yet they would retire to bed early

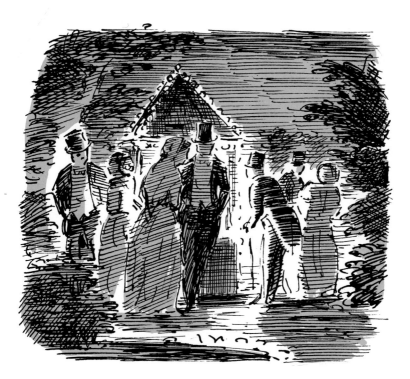

and leave us to our fun in the belief, I presume, that as we were nice boys and girls we would come to little harm. A belief which, to some extent was justified. Our neighbours, strangely enough, never complained.

About my mother there was also a kind of innocence, of which the following is an example. The Telegraph Company, to celebrate the great profits they had made during the war, gave a grand evening fête in the inner ring of Regent's Park. Mother and I were invited to it. It was a full dress affair. My white waistcoat, tail coat and dress trousers had been handed down to me from some relation. With them I wore a secondhand Gibus hat of which I was very proud. My mother wore her best evening gown.

It was a very grand fête indeed. The gardens were lit with fairy lights. Kiosks which dispensed free champagne and whisky stood at the intersections of the paths; on a raised platform Karsavina danced for us; rockets soared into the air and professional tennis players gave exhibition matches on floodlit courts.

I, of course, stopped at all the kiosks and at some more than once. I was in splendid form. When the last rocket had exploded and the music stopped I hailed a taxi and squired mother home with what I thought great efficiency. Unfortunately on taking out my latchkey to open the door I dropped it. When I bent over to pick it up I fell flat on the ground and could not get up again. Though I was temporarily immobile I could hear, and I remember well, mother bending over me and saying, 'Poor boy! He must have caught the Influenza.'

Our introduction to the artistic life of Chelsea was through Fred Mayor, the picture dealer.

Freddy had been at school with me, but as he was two years younger than I, I saw little of him then. In London we became great friends. He knew and was very popular with most of the 'avant-garde' painters of the day and it was by knowing him that we in our turn joined that fringe of young people to be found at their parties. Occasionally Augustus John or Jacob Epstein with their attendant maidens would visit the parties and, as Royalty, receive due homage.

However, in spite of parties and gaiety and late nights and long walks home from Chelsea to Maida Vale after the buses had stopped (I rarely had enough money for a taxi), and in spite of much else, such as being for a short time engaged to be married (the affair lasted less than a year), and in spite of, with my sister Betty, joining a poker school and sitting up till the early hours losing what money I had — in spite of all this, I still had enough energy to continue with my evening classes and paint at the weekends. In fact I was becoming more and more convinced that the one thing I wanted to be was a painter.

Augustine Booth, my fellow student at the Westminster School of Art, introduced me to the artistic colony centred on Charlotte

Street and the Fitzroy Tavern. Among them were Nina Hamnett and Helen, her sister, whom Booth was to marry later, also Ellis the poet, Moeran the composer and Betty May the tiger woman, an associate of Aleister Crowley the diabolist, and others. They were on the whole older and more sophisticated than I, therefore I never knew them well.

Kleinfeldt, to us old papa Kleinfeldt, owned and managed the tavern. He was an enormously stout elderly Jew and a kind man who seemed to like artists. At least he would have their pictures hanging in his bar and would lend them a pound or two if they were broke. The result was that he was very popular with the artistic community and his name became synonymous with that of his pub. For instance, one never said, 'Meet me at the Fitzroy,' but, 'Meet me at Kleinfeldt's'.

Any evening in the saloon bar one would find one or more of the community installed. It might be Betty May huddled over the fire looking very untigerish or Nina showing her drawings to a client.

Booth, Booth Clibborn being his real name, was the grandson of General Booth of the Salvation Army. He was also my senior by some years and in every way an outsize character. His stature was enormous, his voice enormous and his laughter could be heard a mile off.

He had been to many places and done many things and his anecdotes, particularly those about the Salvation Army, or France during and after the war or his acquaintance with Aleister Crowley were always fascinating and often irresistibly funny.

Unfortunately, because of his rumbustiousness, neither he nor his work was taken seriously by his contemporaries. A mention of him was often met with a shrug, a frown and an 'Oh Booth!' with the Booth underlined. Yet they were wrong. He died in 1968 leaving many fine paintings and drawings known only to a few artists and now waiting to be discovered by those with a discerning eye.

Set fair

In the early 'twenties my father had received some large sums in the way of bonuses from the Telegraph Company and in 1926 he decided to share out a portion of this extra money among his children. He gave me and my two sisters £500 apiece.

His intention, of course, was that we should continue to work at our respective jobs and put the money aside as a nest-egg for the future; and his distress was great when, against the advice of my employers and in fact everybody else, I left the company to become a full-time self-employed professional artist. Poor man! He could not understand such foolishness. My sister Betty defected too. She gave up her secretarial job and we both set out for an extended tour of the Continent.

Our goal was Italy, but the direct route through France was barred to me because if I had set foot in that country I should have been arrested for failing to do their military service, a fate I did not want to undergo. The fact that I had been naturalized an Englishman did not matter. I had been born in a French colony of a French father and that was enough for them. We travelled, therefore, the long way round through Germany and Austria.

Our first stop was Vienna, where we stayed for three weeks. We then moved on to Innsbruck and stopped there for another three weeks. Here my sister got off with a very tall and pompous young Austrian who described himself as a Golden Hussar. His English was limited and our German almost nil. However he danced in dutiful attendance.

It was now early spring. During the day we three would explore the high alpine valleys and in the evening, under our Hussar's guidance, we made the rounds of the beer cellars or danced at the local nightclubs.

From Innsbruck, leaving the Golden Hussar, who was probably a clerk in the local gasworks, behind, we went by train through the Dolomites to Venice. Here we found a cheap pensione, the Casa Frollo, on the Giudecca where we spent a blissful month.

Our time was occupied by sightseeing and, in my case, sketching, but never too strenuously. Like most young people we idled happily. We made the acquaintance of a young Rome scholar, I think his name was Maclagan, and with him we would sit and drink in or outside some small unfashionable *trattoria*, well away from Florian's and the other posh ones in the Piazza St Marco, which were too expensive for us.

In the morning we would drink Americanos made of red Ver-

mouth, Campari and soda water or the young red and white Verona wines. In the evening it would be coffee and if we were feeling extravagant a glass of Grappa or that sticky liqueur Aurum to go with it. And, of course, over the drinks we talked, an endless talk embracing all subjects but particularly art with a capital 'A'.

Among the pictures that impressed me most was Tintoretto's great crucifixion in the Accademia, and which gave me most pleasure, the Carpaccios. I was disappointed with the many Titians and Tintorettos in the churches. They were so dark and so ill lit that though I paid them due homage I could not help but be reminded of bits of old lino.

Our favourite excursion out of Venice was to Padua. We would take the *vaporetto* to Chioggia and then on to the mainland where we boarded a small local train which puffed along the banks of a canal. On the left were deep vinyards while to the right and across the canal we saw, as we passed them by, one cream-coloured Palladian villa after another all set among vines and gardens.

Twice we broke our journey at a small halt to picnic among the flowering vines, picking up the next train to take us on to Padua, the terminus. At Padua we studied the Giottos or roamed the streets until it was time to return.

To be truthful, we arrived very ill-equipped for our first visit to Venice. If we had been more knowledgeable we would have received more in return. But the pleasure we had during that blissful month

was immense and could not be diminished by the vast centipedes and the occasional black scorpion in our rooms at the Casa Frollo, or the lumps of luke-warm *polenta* with a little gravy at the *pensione* dinner.

Our journey back to England was via Munich, Nuremburg, Mainz and then by river steamer to Cologne and so home; needless to say we travelled third and sometimes fourth class all the way. We stopped a night or two at each place. The hotel at Mainz was horrible. The food was disgusting, the coffee tasted of carbolic and we were pestered by a dirty slut of a chambermaid. She would follow us about the hotel stairs and corridors. She leered into our faces and laughed behind our backs. She made obscene gestures and suggested we should share the same bedroom and the same bed. I am sure she would have been delighted if we had had an incestuous relationship.

The only tangible result of my stay in Venice was a minute oil painting of the Custom House. I lost it long ago but, if I remember rightly, it looked like Kubla Khan's pleasure dome, gleaming white against the blackest of black thunder clouds. To my intense delight it was accepted and shown by the London Group, that revered and slightly left-wing art society. This was a start. I was at least somebody.

Then I turned to watercolours and produced a number of very dark tinted drawings which Osiakovsky, a far-sighted Pole, showed at the Bloomsbury Gallery. I sold none of them but by great good

fortune the art critic of the *New Statesman and Nation* passed by, looked in and liked them. He gave them a glowing write up in his paper.

From painting and watercolours I took, in search of money, to illustration. I consulted Desmond Coke who had then retired from Clayesmore and lived, looked after by his manservant, in a luxurious flat off the Bayswater Road. He advised me to buy a book called *The English Rogue* by Meriton Latroon, make some illustrations for it and hawk them round the publishers. I did just this.

Luckily all publishers seemed to read the *New Statesman and Nation* and so had seen the glowing critique of my work. They therefore looked at my ham-handed little drawings seriously. In consequence I was asked by Peter Davies to illustrate a volume of short stories by Sheridan Lefanu called *In a Glass Darkly*.

I lived and dreamt that book for three whole months and in the end produced one hundred-and-twenty-five drawings for the £75 offered. Some of these drawings are, I still think, the best I have ever done.

I felt at the time my fortune was made. Alas, it was five years before I was given another book to illustrate.

By now I was married and good fortune smiled on me. I obtained a contract to make forty drawings for Johnny Walker the whisky distillers for the fabulous sum of £400. In the carefree way of the young, my wife and I determined to celebrate it. We booked the best room at the Albion Hotel, Brighton, and stayed there for a week. It was a vast room, carpeted to the walls and with its own bathroom and lavatory. Such luxury I had not known before.

The job unfortunately turned out to be a nightmare. Most drawings had to be done over and over again to satisfy the clients. However I learnt much from it, the chief lesson being that I would never be a successful advertising artist.

Lean years were to follow, and it was not until 1935 that my luck turned once more. I was not only married by now but had two children. It was for the children that I wrote and illustrated the story of *Little Tim and the Brave Sea Captain*. I tried it on various publishers but failed to get it accepted. Then I sent it to Betty Withycombe, the old friend of East Bergholt days. She was working for the Clarendon Press at Oxford and showed my story to Geoffrey Cumberledge, at that time in charge of the New York branch of the Oxford University Press. He decided to publish it. Sales were slow at first but they now go on from strength to strength.

These three happy accidents — my show at the Bloomsbury Gallery and the write up by the critic of the *New Statesman and Nation*, the illustration of *In a Glass Darkly* and the publication of *Little Tim and the Brave Sea Captain* — are the foundation stones of my career as a painter, illustrator and writer of children's books.

In truth one could say that by 1936 I was fairly launched on this career.

My children's book was a success and I had had further shows of watercolours, this time in West End galleries. These had been well received and even some pictures sold. All was set fair.

There were, of course, times of financial stringency when one feared the ship might capsize. But it righted itself and I and my wife and young children, with luck, survived.

In bad times we were much helped by incurable optimism. We were young Micawbers. If cheques bounced, pictures did not sell nor illustrations come to hand we comforted ourselves with the thought that something was bound to turn up.

My poor father considered this a foolishness and would finger his cheque book, fearing a call on his limited resources. The call never came; something always turned up. I wish he was alive today to know that his fears were groundless.